Headwaters
and
Hardwoods

The Northern Tier of Pennsylvania

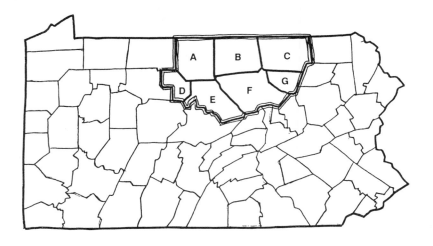

A Potter County

B Tioga County

C Bradford County

D Cameron County

E Clinton County

F Lycoming County

G Sullivan County

Headwaters
and Hardwoods

The Folklore, Cultural History
and Traditional Arts of
the Pennsylvania Northern Tier

Louise – Our paths meet now and again. Best wishes. May you enjoy this book. Pat Macneal

Patricia M. Macneal, Bonelyn L. Kyofski
and Kenneth A. Thigpen
Editors

Northern Tier Cultural Alliance

Published by the Northern Tier Cultural Alliance
With the gracious cooperation of
The Pennsylvania Heritage Affairs Commission
The Documentary Resource Center
The Pennsylvania Council on the Arts
The Institute for Cultural Partnerships
Mansfield University

ISBN 0-9654340-0-1
Library of Congress Catalog Card Number: 96-70566
Printed in the United States of America
Consolidated Graphic Communications, Lock Haven, PA
Design by Charles W. Rupert

Cover photography by David Burke
World's End, Sullivan County
Leonard Treat, woodcarver, Potter County
Cat's Cradle Handspinning Guild, Bradford County
Clifford Merrifield, fiddler, Lycoming County
The Millview Quilters, Sullivan County

This publication is supported by grants from
The Commonwealth of Pennsylvania Council on the Arts
The Emporium Foundation
Adelphia Communications of Coudersport
Rosemarie Lugg Agency, Nationwide, Williamsport

Contents

Map of the Northern Tier of Pennsylvania

Preface — *Patricia M. Macneal* i

Introduction— *Amy E. Skillman* 1

1. Looking Back — *Kenneth A. Thigpen and Daniel Freeburg* 5

2. The Last Raft: A Lumberman's Legacy — *Kenn Reagle* 21

3. The Kettle Creek Coal Mining Company and the Slovaks Who Mined There — *Leonard Parucha* 33

4. Cultural Pockets and Overlays — *Patricia M. Macneal, Bonelyn L. Kyofski, and Kenneth A. Thigpen* 49

5. The Northern Tier Today — *Bonelyn L. Kyofski and Patricia M. Macneal* 71

6. Lycoming County: The Craft of Riflemaking — *Sandra B. Rife* 83

7. Bradford County: Spinning and Weaving in Bradford County — *Sylvia Wilson* 89

8. Clinton County: A Look at Three Faces: Musical Tradition in Clinton County — *Douglas Manger* 101

9. Tioga County: Clear the Other Side of Everywhere Aint So Far from Here — *Bonelyn L. Kyofski* 115

10. Potter County: A Forest Heritage — *Robert Currin* 131

11. Cameron County: One With Nature — *Nelson Haas* 149

12. Sullivan County: The Millview Quilters of Sullivan County — *Ruth Tonachel* 165

13. Other Voices, Other Times — *Bonelyn L. Kyofski* 179

Notes/About Authors/Further Information 191

Map of the Northern Tier

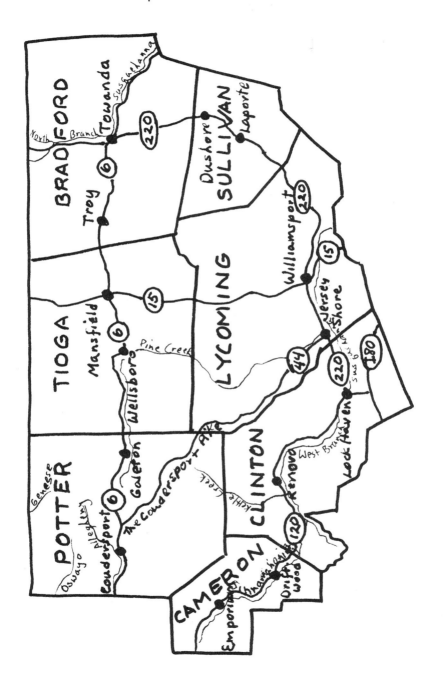

Preface

When I was a fifthgrader in Kansas, we had to speak on "What I did during Summer Vacation." The new girl in class talked about Pennsylvania. It was, she said, a beautiful, beautiful state, where everything was green. There were forests and farms, rolling hills, beautiful old houses, and the brand new Pennsylvania Turnpike. I at once fell in love with Pennsylvania, while knowing it was highly unlikely that I would be whirled away there. A realist, I resigned myself to the dry grass and sandburrs of Kansas September. But the speech proved a foreshadowing of things to come.

Twenty years later I found myself in the center of Pennsylvania, struggling to find my bearings. This center of the state was isolated, rural, forested, and positioned between two cultural regions. Down valley to the southwest were large dairy farms and beyond them Rebersburg, where village houses lined either side of a perfectly straight road one house deep, and some people still spoke with a Berks County Pennsylvania German accent. Older women talked in high voices, and daily polished their kitchen floors. This was Central Pennsylvania.

Our house was in Livonia, a strung-out collection of old farms and hunting camps. An unused church and a one-room school, converted to a private home, suggested that the community had once been more populous. South and east was forest. The road north over the ridges led to Lock Haven, on the West Branch of the Susquehanna. Livonia belonged to this forest world, and the heart of Livonia was Stover's Hotel, run by the same family since 1810. Some evenings we would stop in for boisterous card games, full of jokes and slapping the table, endless hunting stories and talk of old times. It was a man's world. Grandma

Stover ran the kitchen, but she didn't go in the woods like the men. For me, this was a culture without a name.

In early 1992, much later, still living in Livonia, I found myself the member of a team doing a cultural map of that unnamed region to the north. The Northern Tier Documentation Project was sponsored jointly by the Pennsylvania Council on the Arts, the Pennsylvania Heritage Affairs Commission and the Pennsylvania Heritage Parks Program at the Department of Community Affairs. Amy Skillman, State Folklife Program director, had noticed the need for such cultural exploration and for a community planning process. The project covered Potter, Tioga, Cameron, Clinton, Lycoming, and Sullivan Counties in the northcentral part of the state, an area under-represented in state cultural programming. In 1985-86 a Traditional Arts Survey had been done, which suggested that more documentation was needed.

The goal of the 1992 project was "to document the region's intangible cultural heritage and to involve local folk artists, retired workers, and ethnic community leaders in developing a cultural conservation plan." The focus was on people and local folkways. A "Lumber Industry Heritage Park " was projected, and it was our job to see that the human and cultural dimensions of the heritage not be overlooked. We hoped to conclude the year-long project with a small publication presenting some of our findings.

Folklorist Kenneth A. Thigpen, associate professor of English at Penn State University, was project director. My job was to bring people in the southern part of the northcentral area together while Dr. Bonelyn L. Kyofski, associate professor of education at Mansfield University, was focusing on the northern counties. We worked closely together to develop the Cultural Plan. Folklorist fieldworkers included Douglas Manger,

Kenn Reagle, Ruth Tonachel, and Suchismita Sen. WPSXTV producer P. J. O'Connel did the camera work on the videotaping. It was a good team.

By the end of the year, many documentation materials were in hand and a Cultural Plan was on paper. For those interested, a copy of this Plan may be secured by writing the Northern Tier Cultural Alliance.

With the initial grant exhausted, next steps were not clear until a few days before Christmas, 1994, when one of the Millview quilters, Alice Huff, asked Winnie Ferguson, "Whatever became of the videos they took? Aren't we ever going to see them?" Winnie, active in the Sullivan County Historical Society, decided that that was a good question. She phoned me and I called Ken Thigpen. It was obvious that if some of us in the Northern Tier didn't do something, nothing would happen. The videos would languish, unedited, and the essays molder on a shelf. In the next week or two, we began talking and pulled out the Cultural Plan, which said we should organize, establish a home base, and put our program ideas into action. Thus was born the Northern Tier Cultural Alliance. Bradford County asked to join the original group. Others may join us later. The boundaries of the area are still fluid.

This book is written by those who live in the Pennsylvania Northern Tier, and by those who love folklore and traditional arts, local history and local ways. Some of the chapters were written in collaboration. Others were written by individuals. Each chapter is different, and one hears very different voices; the tone, the viewpoint, the approach, the assessment of the topic at hand are varied. Savor those differences!

Thanks go to all who have helped with this book. They include: Amy Skillman and Shalom Staub, formerly of the Pennsylvania Heritage Affairs Commission, now with the Institute for Cultural Partnerships;

The Pennsylvania Council on the Arts, particularly Diane Sidener Young and Bill Daniels; Jeff Soule, Barry Denk, and Larry Lentz of the Center for Rural Pennsylvania; and Mansfield University, that gave us a home.

Founding committee and board members of the Northern Tier Cultural Alliance deserve particular thanks for their help in getting this book ready for publication. Besides my fellow editors, they include: Dolores Buchsen, Robert Currin, Nicole Eastman, Winifred Ferguson, Joe Hare, Robert Martin, Jr., Kenn Reagle, Cheri Reagle, Sandra Rife, Eugene Seelye, Garret Tinsman, David Winton, and Barbara York.

Technical assistance and advice has come from David Burke, Chip Hendershot, Jean McManis, Charles Rupert, Catherine Ford Thorne, Keith Vanderlin, the Terry Wild Studio, and Sylvia Wilson.

Traditional artists and local leaders who have helped out include: Lillian Ayers, Carol Benjamin, Sharon Bennett, Bessie Brown, Freda Cilvik, Howard (Jim) Davy, Wilson Ferguson, Charles Gansell, Alice Huff, Catherine Laubach, Ella Machak, Clifford Merrifield, Marna MaKay, Rev. Father Michael Mokris, Grace Norton, Bill Ralph, Florence and George Smith, Pat Smith, Grace Treaster, and Leonard Treat.

To these and all others who have helped, listened and advised, many thanks.

Patricia M. Macneal

Introduction

By Amy E. Skillman
Institute for Cultural Partnerships
Harrisburg, Pennsylvania

Whether you are a resident in one of the Northern Tier's many communities or a visitor just passing through, your curiosity about this region has led you to this book. We hope it proves to be a quenching exploration of the folklife and traditional ways of doing things among the lush waters and woods of northern Pennsylvania.

As a folklorist and newcomer to Pennsylvania, I have been attracted to the Northern Tier since my first visit in 1988. Most people, when told of my move to the land of my maternal ancestors, said, "Oh, what a great place for a folklorist!" And they were right, though perhaps not for the reasons they supposed. When most of us think of folklore, we think of groups other than ourselves. We never imagine that something so intriguing as folklore exists in our own familiar neighborhoods, churches or communities. It is something that other cultures have. In fact, where there are people, there is folklore. And as a folklorist, my job is to help communities and individuals understand their own folklore and cultural traditions, and find ways to help them honor, preserve and share those traditions. It is a job that enables me to meet some of the most interesting people in the Commonwealth–people with great stories to tell, exquisite arts to share and meaningful traditions to pass on to younger generations.

This is how the Northern Tier Documentation Project began–with a desire to understand the traditions

and folklife, the cultural heritage, of the Northern Tier, and to work with communities to bring honor and support to that heritage.

The term "folklife" encompasses the artistic expressions, practices and customs that reflect the beliefs and values of a community. "Folklore" is generally considered to be those artistic expressions in narrative form, i.e., stories, legends, jokes, songs. We all belong to several "communities," whether defined by family, neighborhood, church, occupation, region, language or ethnicity. So, we share cultural traditions with a variety of groups. One week it might be the food, music, and games of a neighborhood party. Another week, it might be the stories and skills of our sewing group. Still another time it might be the prayers of our family as we sit down to enjoy a meal. We may not recognize it as such, but for this reason, there is great diversity in the Northern Tier as a region.

The cultural heritage and folklife of a particular region is shaped by the geography, the settlement patterns and experiences of the people who live in that region. For instance, one is more likely to find basket making, wood carving and cabinetry traditions in the Northern Tier where the woods are abundant, than pottery traditions more often found in North Carolina or Arizona where the soil is rich in clay. Because of the history of settlement in the region, one is more likely to find the values and beliefs of a Protestant ethos than those of Native American or Asian American traditions. And the impetus to survive the harsh realities of great distances, poor soil and an untameable mountainous landscape have shaped the independent character and rural identiy of people living in the Northern Tier.

Folklife is also the way the human artistic impulse enters into our everyday lives. That impulse is why we create design in the garden, why we sing lullabies to

our children, why we embellish everyday objects with beautiful patterns, why we dance at weddings, and why we harmonize our songs in church. Expressing ourselves creatively does not require years of study in the academy but being good at it requires years of imitation and participation. We all know and appreciate those few traditional artists whose years of dedication and practice are reflected in the exquisite quality of their work. These are the individuals we count on to set the aesthetic standards for our creativity—aesthetic standards that reflect our cultural values and beliefs.

Perhaps one of the most exciting aspects of folklife is that it is constantly evolving with the experiences of our communities. Within the framework of our cultural values, beliefs and identity, we adapt our traditions to meet new circumstances. New technology allows us to work more efficiently, new neighbors introduce us to different ways of cooking, the radio brings us new tunes to add to our repertoire, or the next generation adds new colors and forms to age-old quilt patterns. Still, some traditions do fade and become only memory. But even as memory, they remind us of who we are and where we have come from.

Folklife is not only about things in the attic—although that is a good place to start if you want to learn about your own cultural heritage. It is about people, the things that are important to us and the way we do things in our everyday lives. Folklife represents the intangible cultural resources we draw upon to make decisions about how we live. Likewise, this little book is about what is important to the people of the Northern Tier. As you explore the lives of those who shared their stories for this book, we hope you will find some element of yourself among its pages.

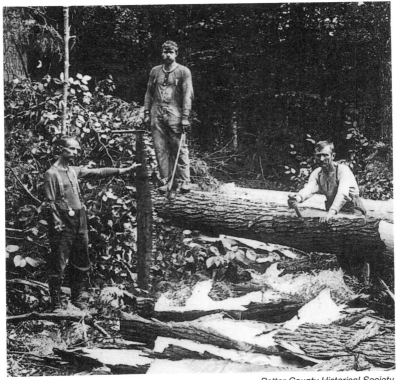

Potter County Historical Society

Felling and peeling the hemlock. The crosscut saw was used to cut the tree. The axeman would cut the sections of bark and the man with the bark spud would peel the bark from the log.

Headwaters and Hardwoods

Chapter 1

Looking Back

by Kenneth A. Thigpen and Daniel Freeburg

In Potter County, Pennsylvania, the story is told that in a certain field where water collects in the spring after the snow melts, it divides and flows by the Gene-see to Lake Ontario and out the St. Lawrence to the Atlantic, by the Allegheny to the Ohio and on to the Gulf of Mexico, and by the Cowanesque and the Susquehanna to the Chesapeake Bay. Headwaters country! This is where life comes from, where springs rise that distribute sustenance across much of the eastern United States. This particular upland field surrounded by forest, labeled as "desert" by early explorers, is the secret heart of the region. Here is a place of abundance, a place where things begin, a chosen country, a good place to call home. Toronto and New York, Baltimore and New Orleans—the rivers may wander to such far places, but they start here. So why is it necessary to leave, or even to tell those who come from those far places about what is here? Haven't they drunk the water that trickled from among the rocks and bracken in this field, even though they might not know it?

Geography

History is often shaped by geography. In trying to get a sense of the historical roots which sustain modern life in the Pennsylvania Northern Tier, geography is a good place to start. This is a mountainous region located along the veins of the northern Appalachian mountain ranges. It is part of the Appalachian plateau, areas of rolling upland cut by deepening stream valleys. Broader valleys are found to the north, adjacent to the New York State Southern Tier, and also along the eastern edge, which is brushed by the North Branch of the Susquehanna. The huge arch of the Allegheny Front and the northernmost ridges and agricultural valleys of the Pennsylvania Ridge and Valley Area border it on the south. The western slope is drained by the Clarion and other tributaries of the Allegheny River.

Pine Creek, the "longest creek in the world," flows from north to south in about the middle of the Northern Tier, through Potter, Tioga and Lycoming counties. Part of this valley is so deep that it is called "The Grand Canyon of Pennsylvania." There is no highway in the Pine Creek gorge from Ansonia down to Blackwell beside the old railroad grade turned hiking trail. One backpacks or braves whitewater rapids to enter it. In Wellsboro, the town closest to the Gorge, there is a mural of the Pine Creek Gorge painted on the building directly across from "The Wellsboro Diner" — an original roadside diner.

Farms in headwaters country were on the plateau, on top of the "mountains." Valleys separating these early homesteads are difficult to cross and the soils are too poor for agriculture, although the abundant greenery masks the unsuitability for farming. Ole Bull, the Norwegian violinist, became painfully aware of this quality of the land when he bought huge tracts of northern Pennsylvania in the midnineteenth century with the intention of developing a farming settlement. The Nor-

wegian immigrants who followed Ole Bull to his dream are all gone, though people still come to visit Ole Bull State Park on Kettle Creek near Oleona. You might still hear on the breeze a Pete Seeger and Alan Lomax rendition of the ballad "Oleanna" — In "Oleanna, the land is free, the wheat and corn just plant themselves, then they grow four feet a day, while on the bed you rest yourself;" and, "So if you'd like a happy life, to Oleanna you must go, the poorest man from the old country, becomes a king in a year or so."

Jim Kjelgaard, an author from Galeton, grew up in these northern farms and described them as "those mountain farms [which] produced more rocks to the acre than anything else."[1] Those who live here today as farmers and foresters feel more than simply wry humor when thinking of factors such as the rocky soil. In the upland wooded hemlock swamps, it is said, one may still find faint traces of huge beaver dam workings built by the giant beavers of the last ice age. And the hardwood trees, the oaks, cherries, ash and hickory stand silent and tall. A sense of awe plays upon the edges of the mind when one walks the trails and old logging roads of the woods.

First residents

In the southeastern corner of the region, around Lock Haven and Williamsport, the Susquehanna gives a "river culture" flavor to the landscape. Delaware tribes, subordinate tribes to the Iroquois Nation, lived here before the area was opened to European settlement. The rich floodplain flats along the river which today produce tomatoes, peppers and other farm produce, were used by the Delaware Muncies, Leni-Lenapes, and Shawnees for growing corn, squash and other vine crops. The earliest explorers and General John Sullivan's soldiers, who invaded the area in 1779, were amazed at the size and variety of corn, the apple and

peach orchards, and the agricultural proficiency of the Iroquois who lived year-round in the uppermost reaches of the Susquehanna. On the western edge of the region a similar culture was seen in "Cornplanter's Kingdom," named after the Seneca warrior and diplomat who lived at the time of the Revolution and into the early nineteenth century. Those early residents left behind artifacts, village sites, and burial sites. Names of rivers and streams, towns and roadways preserve the sounds of their language.

The Iroquois and their subordinate tribes knew that the steep mountain areas were excellent for hunting, fishing, and gathering. The narrow valleys offered security and game for winter camps. Many old place names refer to elk licks, beaver dams, bear wallows, and trout runs. Today, black bear, whitetail deer, turkey, grouse, squirrel and other small game are plentiful. Many of the roads are built along Indian trails. Highway 15, for example, which leads from Williamsport to Painted Post, New York, now being upgraded to Interstate quality, follows the Sheshequin Path north as far as Trout Run and from there the Tioga Trail and the old Williamson Road to Painted Post.

European Settlement

Ginseng traders, trappers and hunters who sought the animal furs and skins that were in great demand in the East during the seventeenth and early eighteenth century were the first men of European culture to arrive in the region. Like the Native Americans, they recognized some of the potential of the region's resources.

More permanent settlers began arriving following the Revolution and a treaty of purchase for most of the area, made with the Indians in 1784. Settlers came into this last frontier of the eastern United States from several directions, giving it cultural diversity from first settlement times.

New Englanders, particularly settlers from Connecticut, which claimed the area as part of their state, came into Potter, Tioga and Bradford counties. They came from the east and north, following upstream the Tioga, Cowanesque, Chemung and Genesee Rivers, and the headwaters of the North Branch of the Susquehanna. In the north, people claim New England roots. The Northern Hardwood Forest of the headwaters area is reminiscent of New England. Silver birches, white pines, and sugar maples abundant here are more common in New England than in the lower part of Pennsylvania. In Potter, Tioga and Bradford Counties people still cherish their New England Yankee heritage, which shows up today in speech patterns, farming techniques, architectural styles, and strong Presbyterian and Episcopal churches.[2]

Settlers from the southeast corner of Pennsylvania, who followed the Susquehanna and its tributaries into the area, thought of Philadelphia as the center of civilization in America. They brought with them a belief in hard work and self-reliance, and established Lutheran and German Reformed churches and a Quaker meeting or so. The Great Awakening at the turn of the century brought Methodist circuit riders and Methodist-like camp meetings and revivals to all parts of the Headwaters, along with the rest of the frontier.

On the whole, the rugged terrain and harsh climate of the nothern Appalachian plateau was a formidable barrier to westward expansion. It was leap-frogged by the Donation Lands distributed to soldiers following the Revolution. Once Ohio was open to settlement, the American frontier jumped west, leaving the highest part of the Northern Tier as an island of wilderness. On the western edge, settlers came in as late as 1850, coming up the Allegheny River from the south and west.

When driving through the Northern Tier it is easy to tell by architecture when one passes from the New

England area to the Pennsylvania German and Scotch Irish area. In the New England style, front doors are on the gable ends of houses and Greek Revival delights in block and triangle symmetry. In contrast, Pennsylvania Germans and Scotch Irish almost always center the front door under the ridge of the roof, frequently exhibiting balanced Georgian facades. To the Philadelphia mind-set, a door on the gable end indicated a public building such as a store or a church.

Gradually, in groups and individually, the English, Scotch-Irish and Germans moved into the mountains on packhorse, on foot, or with loaded canoes. Shrinking the wilderness from all sides, travel was upstream, toward the headwaters of the Eastern United States Divide.

Carrying carefully selected tools, each settler cleared his plot of forest and built shelter amid often harsh, uncomfortable and lonely conditions. Needing cleared land for crops, he cut the large virgin trees, converting some to charcoal. Most were piled up and burned. The wood ashes were useful for soap and potash. Homes and necessary out-buildings were constructed of logs, round and unhewn at first, hewn flat on two sides later, fulfilling European "blockhouse" traditions. The frontier circumstances compelled everyone to extemporize techniques of doing things, and modify British and German cultural heritage.

As more settlers arrived, opportunities developed for productive crafts to spring up, supplying local needs and cutting down on long trips to mills, forges, tool suppliers, and eventually to markets. Some began specializing in trades — blacksmiths, weavers, millers and furniture makers served their local communities by the beginning of the nineteenth century. Throughout the settlement period, up to the Civil War, the American frontier suffered a chronic currency shortage, especially of trustworthy bills that could not be easily coun-

"Early Settlers" Carving by Leonard Treat, Potter County

terfeited. Barter and extensive local credit arrangements with stores and employers filled the void left by scarce dollars.

Penn's way of opening up land for settlement — inviting people with initiative to choose a plot of land they wanted and go through a warranting process of surveying and payment to secure it — made clearing

title difficult for poor settlers. Capital was its own kind of initiative, and rich Philadelphians bought up huge chunks of frontier land for real estate speculation.

Early Industry

The forests were of growing importance. By the 1810s small water-powered sawmills, with up and down toothed blades, were being set up along streams. "Colliers" made charcoal in return for room and board for local blacksmiths and for the needs of the iron plantations that were already booming on the southern and later western boundaries of the region. Hundreds of hearths on which the "piles" of hardwood were burned into charcoal can still be identified in those woods which are within a day's hauling distance from the iron furnaces. Yet, at this point, vast stands of virgin pine and hemlock stood practically untouched as they had for thousands of years.

Gradually, timber became the region's first major industry. By the early 1800s the New England industry had developed machine tools that produced standard, interchangeable parts. The Industrial Revolution was well underway. Ship builders and population centers downriver along the Susquehanna and Allegheny, as far as Harrisburg and Baltimore, Pittsburgh and Louisville were demanding pine lumber. The era of the Clipper Ships began, and the region became recognized for seemingly endless reserves of white pine lumber and white pine mast timbers. Northern Tier white pine was easily worked, resistant to warpage and easily the tallest, straightest and therefore the best "mast wood" available.

Floating the logs downstream to market was the only feasible mode of transportation. After a tree was cut, horses or oxen dragged it to a stream large enough to float it during the spring thaw. As the market grew, small streams too shallow for transporting timbers were

dammed up and loaded with logs. During high water periods, watergates were opened to release a "splash," a flood of surging water and logs headed downstream. Drag scars, hillside log slides running straight down-mountain, and remains of the "splash dams" are still visible today along tributary streams of Kettle Creek and the Sinnemahoning. The Susquehanna was a major rafting artery. At centers such as Lock Haven and Williamsport the logs were sorted, sold, and made up into huge rafts for delivery to the buyers. Tales of the adventure and danger of rafting gave birth to the legends and pride of the "rafting era" (about 1830 to 1860) that still are told and felt in the region today.

Frontiersmen and workers in the Northern Tier were proud of what they did and who they were. When the Civil War came, men in the Northern Tier signed up by the thousands with great patriotic fervor to fight with the Union Army. These sharpshooting backwoods-men were rough in dress and manners. They were nicknamed "Wildcats," and they often wore deer tails on their hats, giving the "Bucktail Regiment" its name.[3]

Some of the self-esteem of those living in the area at the time of the Civil War is expressed in "The Potter County Maid," a popular broadside ballad of the day. One version of it, as sung today by Mrs. Pearl Hess of Nelson, Tioga county, goes:

A valiant woodsman dwelt among the Potter County Pines
Around his shack no roses grew, nor clinging Ivy vines.
And yet, he had a galliant soul, and since this war's began
He swore that he could lick ole Jeff or any other man.

And then he called his brindle steer, likewise his yaller dog;
He left his double bitted axe a stickin' in a log.
And then he donned his yellow shirt, said he, I guess I will
Go over and say goodbye to Sal, who lived at Sunderlinville.

When gentle Sal she saw him come, she dropped her gathered leeks.
She threw an apron o'er her head, the roses left her cheeks.
Said she, why Bill, you're all dressed up, and I know what it's for
You've listed as a volunteer, you're going to the war.

Now Sally dry those pretty eyes, and do not be afraid,
But stand up like a stub'n'twist, Young Potter County Maid.

And give to me before I go some token of your love
That I may pray to it instead of the God above.

Then Sally knelt upon the ground, and from her little heel
She took from it an instrument, a shiny blade of steel.
Says she, take this, my warrior Bill, and it shall be your shield
To protect you from all sorts of harm upon the battle field.

At Malvern Hill, and Gettysburg, and at Seven Pines
That leek hook leaped like living fire along the rebel lines.
Till the Johnnies all would run and shout, here comes the cussed Yank
That wears his bayonet in his heel and stabs us in the flank.[4]

This motif of a protective token given to a hero by his lover which saves him in battle has been used by story tellers and ballad singers from the time of Homer. One notes that the token given here is a leek hook. This leek is a type of wild onion (Allium tricoccum) found in the Pennsylvania mountains and throughout the Appalachians. Potter County people's fondness for the vegetable is part of local folklore, and Potter County diners today typically serve ham, potato, and leek soup. Dottie Bajor, a Potter County resident who comes from New Jersey, has collected the Potter County leek recipes into a cookbook, which is often given as a welcome present to newcomers to the area. It is not surprising that early broadside ballad versions of the poem were called "The Leek Hook."[5]

Boom Time

In the 1860s, following the Civil War, railroads came to the region, and the old ways of lumbering and rafting became suddenly obsolete. Market demands skyrocketed. The whole Appalachian chain began serving as a source of raw materials — particularly lumber and coal — for the rest of the country. These were extractive industries, which removed resources with no consideration of how they could be replaced.

The first timber released by railroads — narrow-gauge "tram roads" into remote woods — included new pine and hardwood reserves, providing not only building material, but also ties for the railroads and

prop-timbers for expanded mining. Railroad-era lumbering, coal train scale coal mining and later related manufacturing in the area brought about profound changes easily traced in Northern Tier life today.

As industry boomed, the need for labor multiplied and remultiplied. Wave after wave of immigrants poured in directly from Europe. In the late 1800s through the first part of the 1900s, the population of the region spurted ahead, with the height of the "new immigration" being between 1900 and 1910.[6] People came from Ireland, Italy, Sweden, Poland, and the Slavic countries of central Europe, places where lumbering, mining, and glass-making industries are found. These workers brought with them not only their skills, but their cultures, and kept part of those cultures alive while assimilating in many other ways with that particular strain of American society formed by the earlier wave of English, Scotch-Irish and Germans, who had come almost a century earlier. As in the past, these new cultural patterns were honed by the demands of the climate, the geography and environ-

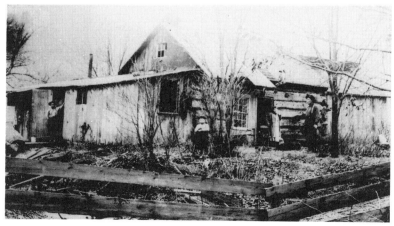

Potter County Historical Society

"Home Sweet Home" Probably on the East Fork of the Sinnemahoning about 1896.

ment. A regional sense of identity formed. This was the place that sent out into the world the raw materials for housing, heat, transportation, and home furnishings. Providing for the needs of the world produced a regional pride that still echoes, despite the buffets of more recent times.

The Golden Age

Markets began changing. Out west, timberlands were opening up. Much of the white pine had been cut off in the Northern Tier, but huge stands of hemlocks were available. With the expansion of the railroad across the American West, the exploitation of the buffalo herd began. Their hides were shipped to tanneries in the Northern Tier for processing, which required tannic acid from the hemlock bark to cure them. Around the turn of the century, the tanneries here were the largest in the world. The need for tanbark was so urgent, often debarked boles were left standing in the woods, only to be reclaimed in the World War I building boom, when the introduction of the wire nail, which could hold in coarse hemlock fiber, made hemlock prime building lumber. Logging railroads were built along practically every stream bed, and strings of lumber "camps" and newly contructed sawmills and towns were built as fast as the railroads. Mills became large and efficient, utilizing new continuous-cut band saws.

Business — investment, acquisition, development — grew naturally with the industrial boom. Some looked to the forests and mines in the region as an excellent investment potential. With acquisition of land, they enticed a railroad to it, built a mill or a mine-head, and hired workers. Sawmill laborers and miners were housed in row "company" houses in company towns, owned and built wholly by one person or company.

"Jobbers" and "woodhicks" in the timber industry lived in lumber camps in the woods, moving with the

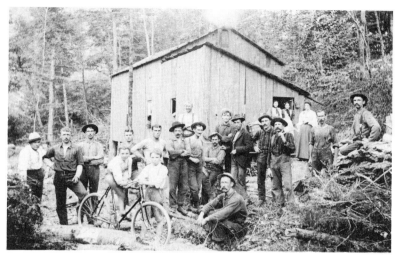

Windfall Run Lumber Camp, Potter County, 1899

timber's felling. Not all moved. Occasionally left behind were small backwoods populations who knew how to live on their own resources.

Mrs. Dorothy Rishel of Loganton, Clinton County, remembers what it was like in the lumber camps. Her Pennsylvania Dutch parents farmed during spring and summer, and went off to lumber camps in winter. Her mother worked as a cook at the camp. Dorothy and the rest of the children went along with their parents. Her memories are not pleasant. The lumber camps were not well-constructed, but designed as temporary shelters for rugged lumber crews. Her mother was up long before dawn to prepare the breakfast for everyone. After the men left for the woods, Dorothy's mother did the crew's laundry and cooked dinner for the evening. The lumbermen were back at the camp at dusk, and by the time darkness fell they were in bed. Candles were expensive, and at the end of the day everyone was exhausted by the heavy work. Her older sisters helped her mother with cooking and cleaning, while Dorothy

says she spent her days playing and "chasing boys." She loved to read and missed life on the valley farm and school. There was not much time to read at the lumber camps. Life was a lot tougher there. Release came with the First World War. Her father went away to the war and they stopped going to the lumber camps.[7]

Memories of those who worked the Kettle Creek Coal Mining Company mine in Bitumin, Clinton County, are also still vivid to those who lived there. The miners' houses were plain four room plank houses, two rooms down and two rooms up with an outhouse in the back. Water was piped from a reservoir on the mountain to spigots every 50 yards or so on the streets. People would carry it home in buckets. Coal for cooking and for heat was free, but they were charged a dollar for hauling the wagon to their homes. In most company towns, in addition to homes and boarding houses, there were saloons, a hotel, and later, churches and a school.[8]

Miners in the 1890s were paid on a tonnage basis, thirty cents a ton for mining and loading. By working hard a miner could dig and load five tons of coal a day, a twelve hour day. Each miner had to furnish his own tools, powder, and dynamite, also oil for his lantern and carbide for his head lamp. Fifty cents a month was deducted from his pay for the sharpening of his tools by the company blacksmith. Food was bought at the company store. Payday was usually a day to find out how indebted one was.[9]

The life of the owners of mines and lumber companies was different. In county seats they built banks, breweries, down-town commercial blocks, hospitals, opera houses, theatres and train stations to reflect the prosperity and pride of the era. More buildings were built in the region in the late 19th and early 20th centuries than in any other period before or after. Owners and builders showed they were up-to-date with the latest in Victorian architecture. It was a statement about being

part of a wider world, which included Boston and New York, San Francisco and Chicago. Today in towns like Emporium, Lock Haven, Laporte, Troy and Williamsport one can visit some of the homes built to showcase the glittering wealth on the "Millionaires' Rows." Many of these elaborate Victorian houses are now museums, restaurants, or apartment buildings. Beyond this private display of wealth, many of the railroad era magnates were interested in their communities. The opera houses, libraries, theatres and churches are a contribution remembered and respected in the communities today.

Decline

In the 1860s Pennsylvania led the nation in lumber production. By 1900 it had dropped to fourth place.[10] By the 1920s, following the First World War, the last of the virgin timber was being cut and the boom was over. Mills were dismantled, railroads were torn up for reuse, and many in the population moved on to uncut forests in the south and west. Others stayed, working in coal mines until they closed, railroads until they declined, manufacturing and tanning. Some industries, like glass manufacturing, rose and fell. Following the stock market crash of 1929 and during the Depression, the Civilian Conservation Corp helped set up the State Park System, providing temporary work for young men in an area with high unemployment. Surviving sawmills gave way to the processing of second-growth quick growing trees like aspen, as pulpwood for papermills and chemical wood for tanneries.

The tannery industry maintained itself within the region until well after World War II. In Tioga County, Elkland had the largest sole leather tannery in the world into the 1960s, and today Westfield is one of the four tanneries operating in the United States. Recently industries such as the manufacturing of powdered

metal and tourism have been on the upswing. Scattered through the area are farms, tree farms, and maple sugar groves, many passed down for over a century within the same family. They speak for the determination and hard work of those families who own them. Modern universities, colleges, hospitals and the State Parks are part of the area's growing "service economy." This is part of post-industrial America. Young people growing up here balance the question of whether to leave the area for better paying jobs elsewhere, or stay here, where the soil is rocky, and work is hard and poorly paid. But family and friends are here. It is home.

Gifford Pinchot, (1865-1946) Connecticut born and Yale educated, was Pennsylvania governor from 1923 to 1927, and again from 1931 to 1935, the height of the Depression. He has been called the nation's first professional forester. He was appointed chief of the United States Division of Forestry in 1898, which later became the Division of Forestry within the U.S. Department of Agriculture, where he served as head until 1910. He then became president of the National Conservation Committee. His understanding of ecology shaped the mature Northern Tier forest of today, which covers more than 80% of the area. His vision that the Commonwealth of Pennsylvania could establish a system of forests, parks, gamelands, stocked fishing streams, and natural areas to benefit all who live here or who come here as visitors has become a reality.

In the forests the hardwoods, red oaks, ash, and tulip trees, pine and hemlocks are taking on size. Among them are ghost towns and hulking, ruined relics of past industry, past glory and past exploitation. Without the stories being told from grandparent to grandchild, those remnants fade from memory as well as into the leaf mold. The trees, however, are growing.

Chapter 2

The Last Raft: A Lumberman's Legacy

by Kenn Reagle

In the summer of 1992 I began an investigation into the event known as "The Last Raft", an event in 1938 which celebrated the height of the Pennsylvania lumbering era in the last part of the 19th century. A double-take, as it were, that had its base over a hundred years ago, and yet flourishes today in folk stories, memories, feelings, and a whole area's sense of "who we are." In a sense, even today, for many living in the Northern Tier, we are those people who strode into the big woods, severed the virgin timber from their thousand year old roots and sent the logs downriver to Pittsburgh, Harrisburg, Baltimore and Philadelphia. We are independent, strong, and capable!

The reason for pride in this part of the region's history is very real. Enough lumber was exported from the city of Williamsport that it became known as the lumber capital of the world. It has been estimated that in the latter part of the 19th century, a hundred thousand people were employed in the forests, on the rafts, and in the sawmills that composed the lumber industry in Pennsylvania. But the actuality of that era is complex, not simple. The railroad's final crossing of the continent, opening up the lush forests of the Northwest, was but one of the factors that brought about the decline of the Pennsylvania lumber industry. The flood of 1889 destroyed the log boom at Williamsport, bringing that chapter of lumber history

to a bitter close. For a while logs and rafts still found their way down the Susquehanna to the few remaining sawmills on the West Branch. In 1910 the last commercial raft made the trip from Renovo to Lock Haven. There were no more, and memories began to fade, and change. There was a great sense on the part of many who had taken part in lumbering that a time of splendor was lost, and something must be done to preserve it.

In the mind of one former lumberman, Vincent Tonkin, the image of one last raft adventure emerged as early as 1905. He longed to take one more trip along the river and to host his old rafting friends along the way. He dreamed of running a raft from the headwaters of the West Branch of the Susquehanna at Cherry Tree, Clearfield County, to Marietta, south of Harrisburg, in Lancaster County. He died without doing so, and the dream was taken up by his two sons. They were the ones to make the "Last Raft" become reality, in March 1938.

R. Dudley Tonkin brought together a crew of former

Lycoming County Historical Society

The Boom" at Linden, near Williamsport on the Susquehanna. Note the "cribs" that act as a fence for the logs channeled in to the shore.

lumbermen. They felled trees, squared timbers, and skidded the logs to the riverside. There they assembled the last timber raft that would travel the river through north central Pennsylvania, a memorial to an era gone by, and a great celebratory event.

The actual event of 1938 was well documented. Books have been written about it, and it had tremendous newspaper coverage at the time. It was also photographed on black and white silent film, a film that documents much of the lumbermen's crafts and skills.

In contrast to that historical type of documentation, my intent was to discover the living story of the "Last Raft," to find the memory that is alive in the hearts and minds of the people who were present. In 1992 I began to search out crew members and spectators to document their personal accounts, and I used the 24 minute documentation film as a way to start memories flowing. The Lycoming County Historical Society placed an advertisement, asking for such people to contact them. Several responded, and I talked about the "Raft" everywhere I went. Much to my surprise, people remembered and were still interested in it. It had been a dramatic, and ultimately tragic, happening, the kind of thing no one forgets. It had occurred in the midst of the Great Depression. It most certainly was eclipsed by Pearl Harbor and World War II, but it is looked upon with great fondness. The "Raft" stirred memories within people of concurrent tragic events, but they also remembered a kinder, gentler time.[1] I interviewed those who were aboard the raft, as well as those who witnessed its journey. I went to speak to several different senior citizen groups in the area to discover any hidden memorabilia. In so doing, I discovered a tradition that is vibrant. As Roger D. Abrahams stated, "What is recorded is a part of the system of action and interaction between human and human, man and nature." The "Raft" is a story of how people

understand themselves as descendants of that old "lumber capital," and it is a story that allows them to be the link between the past and the future. As they tell their story, they become participants with these raftsmen in the struggle to survive in a political and economic world and within the violent world of nature.

The 1938 documentary film shows how the "Raft" was completed in three sections, one cook shanty, and an outhouse. The "Raft" was "tied loose" and the journey began. The camera is on board, and we can see that the water is rough and cold. With each succeeding stop, the crowds that have come out to witness the "Raft" are increasing.

Kermit Allison was sixteen years old when the "Raft" came into his hometown of Renovo, Pennsylvania. He had been swimming at the local YMCA. He was returning home when he saw the "Raft" docked along the riverbank. He climbed down to investigate, asking "What is this?" The men on board responded, "It's a log raft." They told him for a dollar, he could ride it to Lock Haven. "The next morning," he said, "I hit my mother up for the dollar, and I rode the raft to Lock Haven." He was allowed to operate the rear oar sweep. "When the river is high, you just stay in the middle and go." The man instructed me to remember to remain "parallel to the current and follow the deep part of the river."[2]

These memories of the "Raft" were for Kermit Allison a part of a lifelong effort to search out his place in history. He was proud of his heritage in northern Clinton County. By 1992 he resided in Monroe, North Carolina, but he received the Renovo newspaper and has always maintained a close connection to his ancestral homeland.

Upon arrival at Lock Haven, a large and cheering audience gathered to watch the "Raft" "shoot the dam." The film shows how all passengers are re-

quested to go ashore, as the crew navigates the "Raft" over the six foot dam. One unique feature of the film is the instant replay. You witness the descent of the "Raft" over the dam, and then it is played again, as is also the run through the "chute " in Williamsport.

The "Raft" continues its voyage northeast toward Williamsport. An eager crowd has been awaiting its appearance. One man, who was nine years old at the time, related his story about its arrival. His family attended St. Mark's Lutheran Church situated along the river. He recalled being allowed to miss church that day so they could see the "Raft" pass through the "chute" at the Hepburn Street dam. A "chute" was a spillway by-pass that allowed log rafts to pass around instead of over a dam. The "Last Raft" was only 28 feet wide, because that was the width of the "chute" in the Hepburn Street dam. In the film, the "Raft" resembles a large surfboard as it comes splashing through the spillway.

The "Raft" passes under the Market Street bridge and goes out into the open river as it moves past Sylvan Dell and Montoursville. A few miles away several thousand people have gathered in Muncy. They are standing along the river as well as on both the "wagon bridge," present day Route 405, and the Reading Railroad Bridge. Two miles away in Montgomery, the citizens of this little town have come out to await the arrival of the "Raft" which has on board two of its most distinquished people, Dr. Charles F. Taylor, dentist and mayor, and L. A. "Patsy" Henderson, insurance man and publisher of the *Montgomery Mirror*.

On the approach to Muncy, several smaller boats go up river to greet this historical vessel. The camera is our eyes again. We are on board the "Raft" as the "wagon bridge" comes into view. We pass underneath while the crew maneuvers in preparation for the

railroad bridge just a few hundred feet ahead. We are standing on the deck of the "Raft" as it strikes a pier of the bridge head on. The current of the river carries us to the right and we hit the next pier broad side. The cook shanty collapses and most of the crew and passengers are swept into the icy waters. The tragedy of the "Last Raft" is the seven lives that were lost in the accident at the Muncy Railroad Bridge. Those drowned on March 20, 1938 were: Harry C. Conner, pilot of the "Raft" from Clearfield to Williamsport; Thomas Profitt, Universal Newsreel cameraman whose eyes showed us the accident in progress that eventually caused his death; Dr. Charles F. Taylor, mayor of Montgomery and a reluctant passenger; and W. W. Holley, W. C. Van Scoyoc, Malcolm McFarland, and Harry Berringer.

George Amos Smith tells us that he had travelled down from Hughesville to fish and to watch the "Raft" as it went by. After the "Raft" passed him, he returned to Muncy where he recalled seeing the State Police, in their "ghost cars" making their way towards the river through people's yards. He had no idea what had happened until someone said the "Raft" had hit the railroad bridge. His memory was of the confusion the crowds created as the rescue operation got underway.[3]

One mile away on the railroad bridge a young woman, George's future wife, stood with a small inexpensive camera taking pictures as the "Raft" passed underneath her. She leaned over the side of the bridge and snapped a picture at the same time the "Raft" struck the pier. The picture shows the people aboard the "Raft" being thrown forward at the point of contact with the pier. The excitement quickly turned to panic as the crowd realized what had happened.

Lorma Ferrell was standing near the bridge and she remembered seeing the faces of the people on the

"Raft." She recalled that it was a very exciting moment for her. I asked her, "When did you realize the raft was in trouble?" She replied, "The crew members began to yell at each other, a man in the front yelled to the man in the rear, and we realized they were in trouble." I asked, "What do you remember seeing?" She responded, "I saw people thrown, fly in the air, and a woman floating in the water, the sea scouts saving people and the shed fly to pieces." She paused. "You can see that all your life, the people in the water."[4]

Florence Leiby Smith continued the story. "We couldn't believe it happened. The raft turned around and went under the bridge backwards. The little toilet that was on the back end was on the front end." She told me her grandfather, George Hitesman, a former lumberman himself had come out to see the "Raft." He became very disturbed when he saw it. He said,

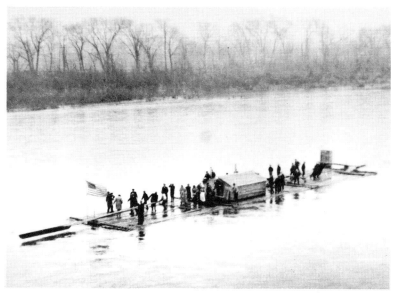

Florence Leiby Smith

Coming Toward the Bridge"

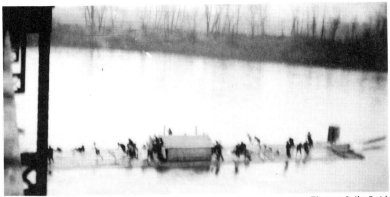

Florence Leiby Smith

The moment of impact

"They will never make it through the bridge, they are too far out in the river, and the river is too high." He refused to stay and watch the "Raft", so he returned to his car and sat it out.[5]

After the accident, the rescue attempts began immediately. There were already several smaller boats in the water and they moved into the accident area and began to pick up people from the water.

Tuesday following the accident, a Coroner's Inquest was held at the Stover Hotel in Muncy. John Bain, newspaper publisher and former Colonel in the Spanish American War described his experience. He was on the front oar when the "Raft" hit the pier. He received several broken ribs from the impact. "Somebody yelled to me, look out for the oar! I jumped and the handle of the oar caught me and I fell on my back, and in an instant it swung back from the other direction and washed me overboard." Mr. Bain was convinced that it would have been impossible to keep from hitting the pier, as they had been caught in a cross current and were being directed by the force of the water toward the pier.[6] There were some rumors of drinking on the part of the crew, but the jury found in favor of the crew and no indictments were ever

handed down. The stories of the drinking persist to this day, however.

By tradition, a raftsman never deserts his logs under any circumstances. Some thought that the "Raft" should stay at Muncy until after the Hearing. The old lumbermen paid little attention to such minor legalities and departed on the day of the Hearing, or perhaps the second day following the accident. There is some controversy as to exactly when they resumed their journey, but the Coroner's Inquest noted one witness as saying the "Raft had departed earlier that day, March 22, 1938." It was piloted by Dick Winters and John Myers from Muncy to Fort Hunter, according to Don Reitmeyer of Watsontown, who rode with the crew on this last lap.[7]

The trip was windy and created problems for the crew. They docked near Selinsgrove with the intention of staying overnight at the Governor Snyder Mansion Hotel. The raft party was treated to quite a drinking spree. One informant related the following story: A man approached him, and inquired as to where he was staying. He told him, the Governor Snyder Hotel. The man replied, "Why stay there, when I have the best bed in town?" He went home with him, only to be confronted with pictures of naked women. He left, saying, "I don't want to be a part of this," and returned to the Governor Snyder Mansion Hotel.

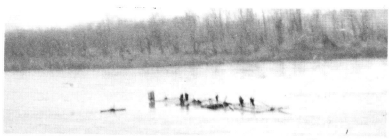

Florence Leiby Smith

The "Raft" floating on downstream.

Van Hughes, a lifelong resident of Montgomery, participated in the "Raft" story as a member of the rescue team and later as a crew member between Montgomery and Lewisburg. Van was 23 years old at the time. For him, one of the most important memories was his sighting of a possible victim, something that appeared to be a body caught on the Montgomery dam. The force of the water kept them from approaching the site without being pulled over the dam themselves. They connected their boat to one of the two large Coast Guard boats brought in for the rescue effort. Their boat was lowered toward the dam until upon closer observation, the possible victim was determined to be an overcoat.[8]

Dorothy Henderson Prather is often asked to relate her memories of the accident. Her father was L. A. "Patsy" Henderson, insurance man and publisher of the *Montgomery Mirror* newspaper, who was on the "Raft." She and other family members were standing in the Montgomery Park when Spook Ellis of the Fire Department came to report the accident in Muncy. Her family was transported to Saeger Station about midway between Muncy and Montgomery. There they learned their father had been pulled from the river, his lungs pumped out, and he was now in the hospital for observation overnight. "My father never wore a topcoat, but he did that day, and because he did, he came very near to drowning." After the family returned home, an uncle called from Philadelphia to say that he had just heard about the accident on the news and that her father, although rescued, had died in the hospital. Mrs. Henderson, Dorothy's mother, assured him that he was in the hospital and that she had just spoken with him, and that everything was fine.[9]

The lumber arrived at its destination on Thursday, March 24, 1938. A short celebration brought to a close this final woodsman's odyssey. At the conclusion of

the film, you see only a pile of sawdust. The search for the victims continued for weeks. The last body, Dr. Taylor, was spotted by a fisherman near the Allenwood Bridge, thirty-one days after the accident.

The people who witnessed the "Last Raft" say it was the topic of conversation for about a month. A feeling of sadness prevailed because of the loss of life. Many of the people who had come out to see the "Raft" did so because of fathers and grandfathers who had been in the lumber industry. The "Raft" made it all seem more real to them. They had been told what it was like, but now they had seen for themselves what it "used to be like in the old days." The reenactment like the lifestyle it represented was filled with tragedy.

During my investigation of the "Last Raft," I was continually amazed at the interest shown in reliving the event. Those who had been there wanted to tell what they experienced as crew members or passengers. Along with individual interviews, I gave programs on the "Raft" at several Senior Citizen Centers. During one of these sessions, I noticed an elderly gentleman transformed as the discussion began to remind him of his home in Clearfield. Fifty five years later, memories became as if they were yesterday. One of the women, Pauline Hoffman, said it best, "I was glad to be there and to be a part of it."[10]

Only one man told me that the entire thing was foolish. He did not witness the "Raft," but as a Pennsylvania Game Commission member, he participated in the rescue operation. He spent five days searching the river for the bodies of the six people still listed as missing. He said to me that even though, "it was big stuff and everybody was interested in seeing it, ... the raft idea was just foolish." For him, the ultimate act of foolishness was revealed in the story that "When they pulled Bud Conner from the river, he still had his ax in his hand!"[11]

Muncy High School teacher Evelyn Derrick has kept the memory of the "Raft" alive for succeeding generations. She contends that her students are engrossed by the story of the "Last Raft." For her it is a keyhole event through which the history of the county can be viewed. For the students, this is one episode from the past that did not happen somewhere else around the world, but only one mile from their classroom. The "Raft" is not only a threshold to step back in time, but it is the springboard to current events, including economic exploitation and decline. It has been invaluable in explaining and defining current realities in eastern Lycoming County.

In 1912 when the Tonkin boys first began making their father's old dream into a reality, they saw it as a reenactment. In their own words, it was an "excursion raft," to host old friends and to acquaint new friends with an era that had passed. A remnant of surviving lumbermen wished to see the memory of those days preserved for future generations through a living portrayal of the historic rafts that traveled the rivers in the lumber era. The deaths of those on it acquainted those who took part and everyone who hears the story with the harsh reality of much of life in the past–and in the present. The stories and songs that have emerged from the Pennsylvania lumber camps and from camps in Maine and Michigan, California, Washington and Oregon often report the death of those noble creatures of "half bone and half gristle." The stories are not about a spring afternoon's public entertainment. The legacy of the "Last Raft" is those private interpretations that each individual employs to make our short life more meaningful. It is the unique participation of the witnesses in the deaths of those old crew members, "axes in hand," holdovers from a different time.

Chapter 3

The Kettle Creek Coal Mining Company and The Slovaks Who Mined There

by Leonard Parucha

The history of the Kettle Creek Coal Mining Company and the Slovak miners is a story of a company town named Bitumen, located in the mountains in northcentral Pennsylvania, Clinton County. It was a town that lasted only forty years, from 1890 to 1930. Today all that is left of it is the wooden Immaculate Conception Church and the cemetery with its Slovak names and inscriptions on the tombstones.

Many people have contributed to the writing of this story. Michael Antos wrote the first known account of Bitumen for Dr. Graydon Mervine in the early 1930s. Dr. Mervine was the company doctor from 1907 to 1916. He had a special feeling for the Slovaks there, who came to him for treatment. Others who contributed to this account were former residents who still live in the area, and many others whose parents left after the strike and evictions of 1922.

Two Men and Bitumen

At the beginning of the story, in the early 1870s, when lumbering operations in western Clinton County in the Westport Cooks Run area were at their height, coal was discovered by men prospecting for minerals for Eastern speculators. Two of these prospectors

were Joseph Russell and David Bly. The coal they discovered was on a mountain top overlooking Kettle Creek, ten miles west of Renovo, which was then beginning to stir as a railroad town. Having limited resources themselves, they looked for financial backing in Williamsport, only 70 miles away by the Pennsylvania Railroad, and the lumber capital of the world at that time.

They quickly lined up eleven backers, formed a corporation, and received a charter on April 29, 1874, as the Kettle Creek Coal Mining Company with a captital stock of $50,000 divided into 500 shares at $100 a share.[1]

After initial mining operations began, toward the end of the 1880s, there was an explosion which killed 18 miners and injured others. They were some of the original miners employed there, Italians, Irish and Swedes. Many workers left after this explosion, reasoning correctly that the mines were not a safe place to work. On January 4, 1888, a letter of patent was issued by the Commonwealth of Pennsylvania to the Kettle Creek Coal Mining Company and a new era of operations began.[2]

George Miller, a civil engineer, had been brought in from Houtzdale, Clearfield County, and made superintendent. He had complete charge of the company. He opened mines, built homes, and established a U.S. Post Office in the company store. The name for the new town came from the bituminous coal mined there and from the fact that the coal company was founded by two men: Russell and Bly–Bitumen.

Mr. Miller was effective. He knew how to parcel out responsibilities and authority. He had his mine foremen for each shift and group of men. He had his own weighmaster. Mr. Miller had his own storekeeper, and like all company towns, all employees were expected to buy everything at the company store. Mr. Miller saw

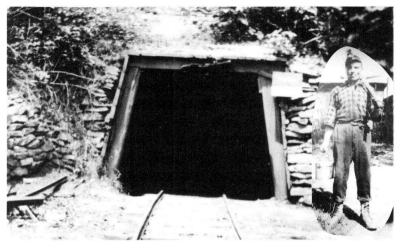

J. Bryjak. Courtesy Leonard Parucha

The Kettle Creek Mine Entrance, Around 1927.

Mrs. Harry Anderson. Courtesy Leonard Parucha

Mr. Jern, a miner, father of Mrs. Harry Anderson.

to it that the way things were run was profitable for the company, for Mr. Miller who worked on a salary plus bonus basis, and of course for the stock holders. The market for coal was good, so the company prospered.

A Company Town

After the accident of 1888, Slovaks were brought in beginning in 1890. It is believed that Mr. Miller brought a few with him when he came over from Houtzdale. He urged them to write to their families and friends in Slovakia, at that time part of the Austro-Hungarian Empire, and tell them that there was work for any who wanted to come. Slovaks were treated as second-class citizens in Austria, times were not easy, and they saw emigration to America as a way of bettering their lives. That was the beginning of the influx of the Slovaks, and by the mid 1890s there were approximately 200 of them in Bitumen, and more coming daily. Sixty houses were built, along with other new mine buildings.

Mr. Miller was the complete boss of the town. He settled disputes with the help of constable David Eisenhower and several Slovaks, all big, strong men. Their job was to watch over company property, keep out unwanted people, and keep order. There was little trouble, only an occasional brawl after too much drinking at a wedding or christening. There was sometimes friction between the Swedes and the Slovaks, but nothing that required outside help to settle. Constable Eisenhower lived in the first house near the top of the hill on the dirt road up from Kettle Creek and Westport. Anyone entering Bitumen by that road had to pass Eisenhower's house, and no one entered without being seen and questioned by him. That included union organizers and Jewish peddlers. Many a Jewish peddler was run off the hill, with his goods thrown after him. Competition with the company store was not allowed.[3]

With the influx of more Slovaks, and their wives soon joining them, the Pennsylvania Slovak Union No. 31 was organized, November 8, 1896. Those who were active in the Slovak Union began to to think through what they needed for a rewarding community life in Bitumen, and to plan for a Slovak church. The church was seen as a priority. Father John Gormley of Renovo had been saying Mass in private homes.[4] The first recorded wedding was on the 25th of March, 1896, in a private home, when 22 year old Steve Hladik took 18 year old Helena Papenk as his bride. Many other weddings were soon to follow as the single miners began sending to Slovakia for their sweethearts to join them in America.

For the men, the twelve-hour work days were demanding. Coal was taken from the underground mine shafts by cable cars and sent down an inclined plane west of town to Cooks Run, to a tipple where it was weighed and loaded onto Pennsylvania Railroad cars

for shipment to Williamsport and eastern markets.[5] The pay in the mid-1890s was on a tonnage basis, thirty cents a ton for mining and loading. By working hard a miner could dig and load about five tons of coal a day. The Slovak miners insisted that they were being "short-weighted" by the weighmaster hired by Mr. Miller. As immigrants in the process of learning English, they may have appeared ignorant, but they were not ignorant as to how much a ton of coal weighs or how much work was involved in digging a ton of coal. The pay seemed low. Each miner had to furnish his own equipment, supplies and tools, bought, of course at the company store. Then there were the deductions. Fifty cents a month was deducted from pay for sharpening of tools by the company blacksmith. Houses for married men were rented for three and four dollars a month. These households would also take in single men to room and board, as a way of helping a family meet expenses. There was also a rooming house for the single men operated by the company. In short, it was a company town, and many miners were forever in debt to the company.

An Englishman named Tom Guildford brought his wife and five daughters to Bitumen, and he figured out how to outwit the company, in a way that affected company policy. He had worked for the Kettle Creek Coal Mining Company elsewhere before settling in Bitumen, and in all his years as an employee had never drawn any pay, nor been able to get out of debt. He was shrewd, however, and planned his revenge. He was an Englishman, and refused to become a United States citizen, although many tried to convince him that he should. He never gave a reason, but he did mention that anyone born in Great Britain would be a fool to become a citizen. What he didn't say was that he knew there was a treaty in force between Great Britain and the United States which said that "the

citizens of each country residing in the other, must be paid for labor performed in the coin of the realm." It was the custom of the coal company to pay once a month. Each month Tom Guildford received a "statement" of indebtedness to the coal company. He carefully preserved these statements, and had a complete record of his years of work without pay. When he felt the time was right, he contacted the British ambassador in Washington, and submitted to him all his statements, which showed the company to be in violation of this British-American Treaty. The ambassador took the case to the State Department and the company was ordered to pay Guildford fourteen years back pay. When the company tried to sue Guildford for indebtedness, he had gone back to Britain.[6]

After this incident, no miner was permitted to work unless he could produce a citizenship paper. Wagonloads of miners were transported to Lock Haven, the county seat, where they took an oath of allegiance and received their first papers. Another result of this episode was that the company settled their accounts every two weeks.

United as Mine Workers

Faced with low wages, long hours, and dangerous working conditions, the miners were interested in what several union organizers of the United Mine Workers of America had to say in early 1897. The first organizers were soon run off the property, but the union organizers came back, this time with some organizers who could speak Slovak and Polish. Their meeting with the miners was held off the company property. Constable Eisenhower was barred, but he managed to know who was in attendance. The information was relayed to Mr. Miller, who promptly fired the most prominent of the miners attending.

Perhaps because of the experiences of immigration

and of organizing the new community for the purpose of planning for churches and schools, the miners were not easily scared, and were organized as a United Mine Workers Local before the end of the year.

It was a good year to join the union. In 1897 the United Mine Workers with ten thousand members, including more than two hundred at Bitumen,[7] struck the Central Competitive Fields of Pennsylvania, Ohio, West Virginia and Illinois, paralyzing all operations in these areas. The operators gave in and together with the Union formed the "Interstate Agreement", which established an eight hour day for miners, a uniform wage scale for all day laborers, and a scale of wages for miners in each district which would equalize costs of production among all operators and thereby establish equality of competition. It was a great victory for the United Mine Workers and increased their membership by 1,000 per cent. At Bitumen every new miner was required to join the Union before entering the mines.[8]

The immediate gains were not spectacular but there were some. The pay was set at 50 cents a ton, a raise of 20 cents, and the safety conditions in the mines were improved, but they still were far below the accepted standards. The company store policy did not change, but a few chinks developed in the system. An occasional Jewish peddler appeared in town selling small items, and the miners' wives somehow found out about the Sears-Roebuck catalog being passed around with items selling for half of what the company store was charging. These could not be sent for from the Bitumen Post Office for obvious reasons, but the postmaster at Westport was accommodating and would help them in their orders and hold their packages until they came to pick them up.[9]

Prospering as a Slovak Community

With the acceptance of the mine-workers union in 1897 and improvements in pay and working conditions, the community was beginning to look for other ways to improve Bitumen. The Roman Catholic Immaculate Conception Church was built by the congregation with the help of the whole community. Rev. John Saas, a man of German background from Lock Haven, became the first resident priest. A parsonage was built next to the church which also served as a school until a school building was erected several years later. Father Saas and Mary Gephart were the first teachers with Andrew Antos also teaching the Slovak Language to the Slovak children who began to arrive. Mr. Antos, educated in Slovakia, was also the church organist and choir master. Songs in the church were sung in Slovak and Antos also read the scriptures in the Slovak, a language which Rev. Saas had not mastered.

About the same time, in 1898, a Swedish Congregational Church was built and several Swedish Men and Ladies' societies were organized. There were also a few Eastern Orthodox families in the community. Their spiritual needs were taken care of by a visiting Orthodox priest from Punxatawney, where the records of these parishoners are still held.

All social life of the town revolved around the churches. Every Slovak wedding was a community affair, and they happened almost weekly in the late 1890s and early 1900s. Sometimes there were two or three on a weekend. They were carried out in old country tradition with the bride in her white wedding dress, sometimes pinned up five or six inches to keep from dragging in the mud while walking to the church with her "entourage", and often in her heavy shoes which were changed for the more formal white ones in the vestibule of the church. The church ceremony

was very solemn. The celebrating began in earnest several hours later at a reception and dance. Everyone who danced with the bride would put a dollar or more into her deep apron pocket, apparel donned especially for the occasion. A bride would sometimes collect enough money to set herself and her husband up in housekeeping even after paying for the music and refreshments.[10]

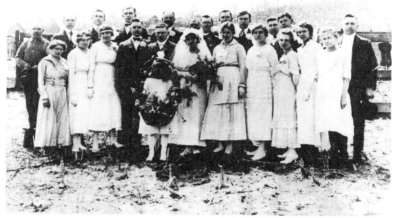

Leonard Parucha

Wedding Day of Ann Dostal and John Smrecansky, April 15, 1918.

There were Slovak men's and women's societies organized, patterned on old country traditions but with a special purpose–to keep their culture alive in the new country, as that was the only culture they knew. They had brought along with them their old country ways, including their religion. They brought their own approach to life, their sense of who they were, their way of doing things, and their love of drinking, singing, and dancing. It seemed that the twelve hours they spent at hard work in the mines or on household chores supported the other twelve hours of eating, drinking, dancing, praying and sleep-

ing. Theirs was not a culture of passive entertainment.

A dance hall was built in the early 1900s, for which there was no lack of musicians. Many of the early immigrants had played the violin or viola in the old country, and some played the cornet and other brass instruments. Mr. Antos was a musician who taught others to play and formed an orchestra. This orchestra played at the weekly dances at the new Slovak union hall. Everyone was welcome at the dances, Slovak or not.[11] Many Slovak girls married Swedes or men from other ethnic groups, with no objections. And children were born, which in turn led to another celebration, "the christening," with food, drink and dancing for all.

So Bitumen was full of families, with children playing everywhere, just as in the old country.

There was lots of good Slovak cooking, too, including culinary delicacies such as "perogi," "kobassa," and "holumki." Vegetables and fruits were raised in home gardens. Many had a cow for milk, pigs for winter butchering, chickens for eggs and for Sunday dinners. They made "kfasna kapusta" (sauerkraut), and sometimes their own "pivo, vodka, and vino" (beer, whiskey, and wine). It was like Slovakia, only better. It was a happy life.

By 1910 the population of Bitumen was 1,200 according to the census, but it was believed to be more as many of the single miners had "shacks" in out-of-the-way places and did not want to be counted for fear that it would cost them some tax money. The number of men employed exceeded 500. Not all lived at Bitumen. Many lived in the Cooks Run area at the "shoots" near the bottom of the tipple. With coal being in great demand in the East and most mines supplying this coal under the same union contracts, the price of coal was stabilized and both miners and mine owners felt they were making money and were prosperous.

With the introduction of new safety measures in the mines, which added to the expense of the company, coal mining was safer, but still a very dangerous occupation. On December 16, 1910, an accident took place above ground on the inclined plane as it was lowering seven fully loaded coal cars on the cable with four miners who climbed on. The miners were on their way home to the Cooks Run area at the bottom of the plane when the brake shoe on the drum wheel on which the cables revolved snapped, making the brakes useless. Two miners were killed, the other two were injured, but not seriously, when they jumped off. If the accident had happened fifteen minutes later, as many as twenty-five miners would have lost their lives, as they were to take the last trip ending the day's work. And approximately 50 miners went down the inclined plane on loaded cars in the previous hour.[12]

George Miller, the general manager and engineer of the coal company died in 1914. He was mourned by the miners as a lost friend. He was "highly respected and much liked for settling all labor difficulties satisfactorily and according to humanitarian principles," according to the account by Michael Antos. Mr. Miller's duties as general manager were taken over by his son W. M. Miller, with Harry From as superintendent. The company store was enlarged and remodeled, and called the Bitumen Supply Company. A new, modern tipple was built.

The country was moving to the pre-World War I tempo of prosperity, and with coal in great demand, the company and its stock holders were prospering. Periodic raises took place for the miners, and the miners were "making money" as the saying goes.

This was reflected in the life of the community. A large public school house was built for all the children of Bitumen whose parents did not want them to go to a private parochial school and for those who were not

Slovaks. There was a choice of schools after 1918, when a small addition was built on the back of the church for a Slovak school. Vincentian nuns were brought in from their motherhouse in Perryville, Pennsylvania, to teach the Slovak language, among whom were Sisters Ann, Carmilla, Gertrude, and Mother Superior Vincentia. Besides teaching, the nuns cleaned the church with the help of some of the older girls of the parish. They also decorated the church for the different holy days.

Traditions in a Time of Change

Even though most social activities were church oriented and influenced by Slovak traditions, by the early 1900s these traditions began to be augmented by more typical American activities. The town band was formed by Michael Antos and Coryel Ross, a non-Slovak. It paraded on the main street of the town at every national holiday with the American flag carried high and proudly, followed by numerous Slovak and Swedish banners. The band also paraded on holy days, weather permitting. Most holy days were no-work days: church and religious processions, then to the dance hall after dinner, or a baseball game.

A Young Men's Lyceum Club was organized to promote sports, and a baseball team was started with the Rev. J. Palfy as manager and chairman of the club. So there were baseball games every Sunday in the summer, and dances every weekend. The children learned to play American games from the other children; marbles, baseball, kite flying, hoop rolling. They made snowmen in the winter, and went "skinny dipping" in Cooks Run in the summer. The children became Americanized very quickly. It was a good life, everyone agreed, even though the work was hard.

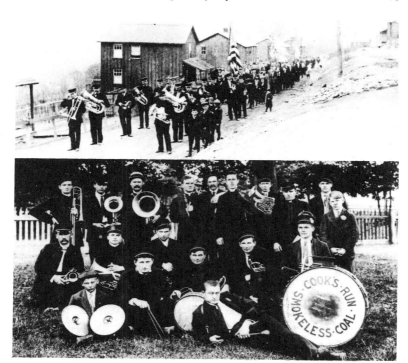

Leonard Parucha

The Bitumen Band, about 1909, played in at least a dozen Bitumen parades, and also at parades in Renovo and Cross Forks. They were known for their polkas. Father John Lechman is in rear right center.

A Citizens Club was chartered to promote citizenship and fellowship among its members with August Antos as chairman. This club, the Lyceum Club and the band were enthusiastically backed by the Kettle Creek Coal Company, ever mindful of the Tom Guildford episode.

Such steps toward "Americanization" did not mean the Slovak traditions were forgotten. The first Roman Catholic priests assigned to the Slovak church were admired and appreciated by the immigrant families, but they wished they had a priest who could preach in their own language. This happened after Fathers Lechman, Palfy, Sabados, Wilczenski, and Kallock

were assigned to the parish in succession after 1910. Then all of the days of Advent were observed. On Christmas Eve a "kolenda" (Christmas carol) was sung by groups of children outside the different homes in the area. There was the vigil, the supper on Christmas eve with the Oplatek, a holy wafer made by the nuns, passed around and partaken of–then the mushroom soup, the prunes, the fish; all with their different meanings brought from Slovakia. At the celebration of the Three Kings Day on January 6, two weeks after Christmas, the priest would visit each home to bless the house and put the date and the initials of the searching Three Kings on the doors–"19+C+M+B 20".

The most solemn of all periods was the holy week before Easter. Fasting, daily praying at the church, and finally the vigil from Friday afternoon until Shepards Mass at sunrise Easter Sunday. It was an experience impossible to describe. After World War I it became the custom to station two returning soldiers, armed and wearing their blue uniforms, to stand guard over the tomb in the church from Friday afternoon until Resurrection Sunday morning. After receiving Holy Communion Easter Sunday morning, the parishioners went home to feast on food previously prepared–decorated hard boiled eggs, ham, kobassa, horseradish, sweet breads. A custom brought over from the old country was the "Swienconka." On Easter Saturday morning most parishioners would take a basket containing samplings of their food to the church to have it blessed by the priest; ham or goose or lamb boiled in a copper boiler, egg roll (which took many eggs and hours to make,) decorated eggs ("pisanka"), kobassa, "chrzan" (horseradish), all of the choicest food and covered with their best piece of white linen .

Sudden Changes

World War I was a good time for coal towns. Employment was high, but the cost of living rose from a base of 150 (in 1918) to 205 (in 1920). The miners' union wanted a wage increase to compensate for the increase in the cost of living.[13] Suddenly the war was over. Demand for coal was diminished. Competition for markets was fierce. Coal prices dropped and the company could not pay the price of mining.

On April 1, 1921, the Kettle Creek Coal Company signed a new contract with the union but closed the mines, claiming they could not pay the new scale, which was $1.28 per ton piece work and $0.93 per hour on hourly scale. The mines remained closed until April 1, 1922, the duration of the contract. The company then gave the miners the option of going back to work at half that scale or of being evicted from the company houses, for which the miners were one year behind in rent.

The miners refused. The company went to court and procured orders to evict the miners from the company houses and off the company property. Sheriff Tom Johnson with his deputies and four state police, all armed with sawed off shot-guns, evicted sixty families within several days. Even those who built their own homes were evicted, as they were on company property. The miners showed considerable restraint in not resisting the lawmen doing the evicting, largely due to the advice of Father Sabodos and the wives of the miners who wanted no bloodshed, mindful of events in Slovakia under similar circumstances.

Eventually some miners accepted the company's offer and went back to work at the reduced scale. But things were never the same. After the evictions many others left. The Vincentian Nuns who taught there for four years left. Work was sporadic and most of the remaining miners began to drift away. The Depression

finally put the finishing touches to the mines and the company in 1929.[14]

The houses were sold to the Carl Kephart family of Avis, to be torn down, which was done in 1930. The land was sold to the Pennsylvania Bureau of Forestry. The last of the coal was strip mined, and some of the deeper strip mine gullies were used for dumping for a while by the Borough of Renovo. The Swedish Congregational Church was torn down by the Kepharts and the lumber used to build the double garage-like building on the Renovo Road at Sugar Run, near Lock Haven.

The Slovak Immaculate Conception Church of Bitumen, in disrepair, was also ordered to be torn down by the Bishop of the Altoona diocese.[15] In response to that action, the Slovak community hired a lawyer, and the order was rescinded when the people agreed to keep the church in repair. Today the church, the cemetery, and a few remaining houses are all that is left of the once prosperous coal town. Once a year on the first Sunday of July, services and a reunion of Bitumen Slovaks are held there. In 1981 this Bitumen Reunion was featured on a TV regional program by WPSX Channel 3 from Penn State University, and in 1986 the story of the community appeared in the *Pennsylvania Heritage Magazine.*

As an old Slovak said at a recent reunion, "wszystko z wiatrm poslo..." All gone with the wind.

Chapter 4

Cultural Pockets and Overlays

by Patricia M. Macneal, Bonelyn L. Kyofski, and Kenneth A. Thigpen

The Nature of Culture in the Northern Tier

The cultural pattern of the Northern Tier is like a watercolor with background washes, over which are spread the ethnic traditions, the edges undefined, but with bright splashes of color here and there.

One of those basic background washes is the original American Indian influence, present in traditions of tobacco-tool making, herbal healing, and food preparation. George Klinefelter of Sugar Valley, Clinton County, talking about arthritis, told of how he learned about "Hard Root" from a young man from Beech Creek, how it grew along streams in mid-summer. You had to tug up the long, very hard roots. After you cleaned them, you cut them into pieces with a hatchet, steeped the pieces in gin for two weeks, strained them, and kept the liquid corked in a bottle until you felt your back or knees giving you trouble.[1] Oral tradition doesn't speak to the use of gin in Native American lore, but the adaptation of Indian lore with a substance only the settlers would have illustrates nicely how a folkway is accommodated into a new culture.

Other "background washes" were the early European migrations from England via Connecticut and New York State, and from Northern Britain, Ireland and the Rhineland via Philadelphia. Many activities dating back to frontier times are practiced today. Split-

ting rails and firewood, sawing and lumber milling, logging with horses, blacksmithing, old time fiddling, and woodcarving are traditional men's activities associated with life in lumber camps. Parlor piano traditions, table setting for family meals, quilting, rug weaving, doll making, lace making, broom making, the siting of wells and well-drilling ("water-witching," though there's no suggestion of the occult), shearing, butchering, maple syrup making and ice cutting are traditional arts or folkways more associated with farm life. Storytelling and music worked in both worlds. Dating from the early 19th century, all are still practiced today as part of daily life.

Other early 19th century activities are no longer part of the daily or seasonal ways of doing things, but are done as an art, a hobby or to educate about frontier life: apple doll making, most basketmaking, threshing grain by hand, candle making, spinning, weaving and similar "early Pennsylvania crafts." For many, these activities are "how it was done in the old days. The way my granddad did it, and his dad," with rare reference to specific dates or events. For many whose families come from 18th century English, Scotch-Irish and German roots, "back in the old days" is parallel to "back in the Old Country," used by those whose families came during the late 19th century.

For some folkculture professionals, what is found in the Pennsylvania Northern Tier is not a culture, but many cultures, exemplifying the many ethnic backgrounds. Others see this as a complex regional culture. It is like a patchwork quilt, formed of contrasting shapes and fabrics, but with an over-all pattern which gives it unity and sets it apart. David Hackett Fisher writes "... the new immigrants did not assimilate American culture in general. They tended to adopt the folkways of the regions in which they settled ... a process of regional assimilation."[2]

Early Place Names

Place names vividly refer to landforms and settlements, classical antiquity, significant events, "first names" to honor loved ones, and a few generic descriptors. Fall Brook, Driftwood, Round Top, Little Marsh, Deerfield, Marshlands, Stony Fork, Crossfork, are examples of geographical indicators. Settler names are remembered in Hammersley Forks, Beechers' Island, Harrison Valley, Keating Summit. The Indian names include Tiadaghton, Sinnemahoning, Towanda, Cowanesque ("kawaneskee"), Tioga, Wyalusing, Susquehanna, Genesee. All are two hundred year old names, a background to the cultural quilt.

Towns named for families generally have the surname attached to a European suffix indicating a settlement: Sizerville, Salladasburg, Williamsport, Cogan Station, Andrews Settlement, Antes Fort. Some towns adopted the family name plain: Lopez, Watrous, Austin, Morris.

Several towns were named for beloved places left behind: Jersey Shore, Ulster, Antrim. Athens, Troy, Rome, Hector, Ulysses: were they named by gone-astray classicists who envisioned great cities or were the names borrowed from the migration through New York State? It is well-known that a classics-loving clerk in Albany held forth with a naming pen in the middle of the 19th century. Settlers may have enjoyed thinking of pleasant villages in the Hudson or Mohawk Valleys. Lovely ladies were pedestaled in Mildred, Berenice, Avis and Eulalia. Gold's name was literally pulled out of a hat,[3] and Shingle House, built and shingled by a Frenchman in 1806, speaks for itself.[4]

Sullivan County's Celestia and Eagles Mere claim the prizes for poetic nomenclature. Celestia was planned as a theocracy, a religious utopia. The minister declared the place independent of the United

States and deeded the land to God. When the community refused to pay God's taxes, trouble ensued and the community wilted. The five and a half acres, formerly God's, were recently deeded to the Sullivan County Historical Society by the Dwight Lewis Lumber Company.[5]

Eagles Mere was a glass manufacturing town at first. Its beauty and the access by railroad made it early a thriving resort, with the most apparent claim to elegance one finds in the Northern Tier.

Fisher's observation about the tendency toward regional assimilation is very apt in northern Pennsylvania, as is the sociologists' observation that there are many more differences within each individual group than there are among the groups themselves. In the early 1990s, inner-city at risk African American families were transferred by the courts to towns and cities in rural areas, including Williamsport, which has had a black community since before the Civil War. It became clear with the influx of families from Philadelphia that the African American families of Williamsport were of a different culture from the new arrivals, despite similar ethnic origins.

Cultural Attitudes of the Early Settlers

Early settlers found that farming and lumbering went together very well. Cutting trees cleared land and provided firewood and income. Later, as lumbering became big business, farming and lumbering became differentiated. The farmer usually stayed on his own land year-round, while lumbermen worked seasonally in austere lumber camps. The farming life style was more civilized; the lumber camps exuded an aura of rough and romantic frontier existence.

Ken Thigpen collected a song about "The Farmer's Son and the Shanty Boy," an example of how the two lifestyles were regarded by some during the last cen-

tury. The song is a dialogue between two girls about the relative merits of marrying a farmer or a logger. The farm girl begins with prim disapproval of the logging life but after agonizing, in the final stanza admits the romantic advantage of the shanty boy lover:

"Oh, what I've said of your shantyboys, I hope you will excuse
 and from this ignorant farmer's boy if ever I get loose...
 If ever I do leave him, with a shantyboy I'll go,
 Leaving mossback broken-hearted, his buckwheat for him to sow."[6]

John Heaps in his book on the Headwaters Country mentions that, according to the Tiogans, "a northern tier lumberman could drink more whiskey, fell bigger trees, argue louder, and tell better lies than anyone else in the world. No Wildcat, the stories go, ever lost a fight or a pretty girl."[7] Whatever the virtues of the two occupations, most people making a living in either in the mid-19th century were not assured an easy life. Later, lack of knowledge about the real lumbering life led people to make up exciting and romantic stories about lumber camps, stories which often had little connection with reality.

A valued lumber camp job was that of the cook, whose productions were a mighty attraction to free-lance loggers. Many widows raised their children by that demanding work. Yet, "ladies" were defined by Victorian standards of "association." Many adults who grew up in lumber camps will today not share the experience because of the negative judgments they feel might be made of their mothers. Ironically, a woman might do all the same back-breaking labor on the farm, helping in the hayfield or nursing a sick cow; as long as her husband had an interest in that farm, she could be considered a "hard-working lady."

What could be perceived as rivalry between logging and farming could also be seen as discrimination. Perhaps the traditional English/German valuing of land ownership as paramount was operating: perhaps a slow evolution was taking place in a configuration of relationships which determined what constitutes value in a democracy.

Late 19th and Early 20th Century Immigration

As the lumber industry, then the coal, tanning, glass and other industries grew between the Civil War and World War I, immigrants from Europe came to fill the need for labor. With the Industrial Revolution at its maturity but the high tech revolution still far off, there was a need for physical strength and determination, "unskilled labor." Many of the immigrants to the Northern Tier came from mountainous areas in Europe undergoing social upheaval, from other parts of the United States and Canada. They were in need of jobs, willing to take risks and to work hard. Many were familiar with lumbering, mining and the other industries available in northcentral Pennsylvania. "Unskilled" they may have been, but they were not unknowledgeable.

Germans, Irish, Welsh, Italians, French, Poles, Swedes, Norwegians, Danes, Lithuanians, Slovaks, Hungarians, Swiss, and African Americans from the South came looking for a better life. They settled where their countrymen were already established, and wrote home, attracting others by the conditions they related. All brought their own cultural mind-set and ways of doing things.

The descendants of the earlier immigrants reacted in various ways. The sentiments in "The Farmer's Son and the Shanty Boy" arose all over again. Stereotypes of each ethnic group were established, together with labels; the inability of immigrants to speak facile Eng-

lish was scorned. Local newspapers published sting-
ing little barbs, some in the name of humor, about
Poles and Italians in particular.[8] Ethnic "put downs"
were common. Competition for jobs with higher
wages was keen, and there were turf battles. Men in
their late eighties can recall the necessity of being a
Protestant to get a job beyond that of common la-
borer.

Today awareness of ethnic identity is on the wane
for many of the population groups of this region. This
seems sad. But children of the immigrants at the turn
of the century learned well the lesson taught them. It
was not to their advantage to be different. The second
generation wished to "be Americans" and to erase the
ethnicity of their English-as-a-second-language
homes. Few maintained their parent language skills,
though the folkways are a different story.

The 1980 census figures of Wellsboro show that the
town included Japanese, Korean, Asian Indians and
Vietnamese people. The Italian and Polish immigrants
of a hundred years ago have largely merged with the
original families and identify themselves exclusively
as white American. The ethnic landscape is made up
primarily of people with German, English, Scotch,
Welsh and Irish ancestry.[9] As a rural county seat,
Wellsboro would have a more cosmopolitan popula-
tion than most region towns, but it should be fairly
representative of the larger communities.

With the occasional exception of school and univer-
sity activities, "Folk Festivals" in the Northern Tier
rarely honor specific ethnic heritages. Most educate
and entertain the folks who live in the area.

Ethnic "Splashes" on our Palette

"Folk" in the Northern Tier, then, refers to that amal-
gam of frontier culture overlaid by European ethnic
cultures coming into the area later. In daily living the

ethnic roots can be traced–in parenting practices and family role assumptions, in food preferences and household practices, in gardening styles, in gender role expectations and career choices, and in religious affiliation and attitudes toward various values. In such things ethnic cultures tend to persist, despite conscious decision, television, or societal suggestion.

The 1989 *The Atlas of Pennsylvania* does not acknowledge any ethnic influence in the northern counties because for a group to be significant by the *Atlas* standard, over 1,000 people in a county must identify themselves by that ethnic heritage. Tioga County has barely 40,000 people; Potter has a little more than half that; Sullivan and Cameron fewer. Bradford and Clinton have some 60,000. Nearly 100 years after the wave of immigration, few in our area do not feel assimilated for census reporting purposes.

Examples of ethnic influences are still found. All are overlays on the regional culture, giving it sparkle and depth.

Native American

Just as the Iroquois dominated the Northern Tier two and a half centuries ago, they still predominate in the popular conception of Native American culture. It is difficult to know whether this is because of their prowess in battle at the time of the Revolution or because of proximity to the New York State Salamanca Reservation and the Kinzua Dam construction and displacement in the 1950s.

That is changing. Many Northern Tier people are increasingly identifying themselves as Native Americans with specific tribal connections. As a result, Lenni Lenape and Delaware in particular are mentioned in the media more frequently. The Native American Institute at Mansfield University is studying the population of the area and has reported that there

is a surprisingly broad representation of nations here. We look forward to seeing the results of the study.

Jewish

As soon as early settlers began coming into the area, hardy Jewish merchants, primarily from Philadelphia, outfitted themselves with merchandise in a backpack, and set out for the frontier. They traveled from town to town and farm to farm. According to the elders from the farms and logging histories, the peddlers were more than welcome. Like minstrels of medieval times, they brought news and bonhomie, not to mention pins and needles, dress goods, and occasional other sweet luxuries.

Often a peddler would settle in a growing town, set up a store, and raise a family. Several Jewish families in this area today say this was the story of their great-grandfathers.[10] In Renovo, Philip A. Marks runs the Sol Marks Haberdashery. Joe Abrahamson in Westfield, who had started as a peddler, and his wife Minnie ran their clothing store until Joe's death in the 1960s. Usually there was only one such clothing store in each town, and the storekeeper and his family were valuable members of the community, disproportionate to their numbers.

Today the Jewish population in the Northern Tier is declining. Many practicing Jews have moved to larger communities out of the area, where synagogues can sustain themselves. As a result, Jewish professors at Mansfield and Lock Haven joke about political clout: "We *will* deliver the Jewish vote." It's no challenge. Their numbers are woefully few.

Italian

Italians arrived in the North Country in the 1890s and on into 1920. Some families left when the jobs faded, but others stayed in certain towns. On the streets there one sees a higher level of body language

and volubility, as well as Mediterranean complections.

In Tioga County's Elkland a street of company houses was known as "Cabbage Row" in the 20s and 30s, both for the houses' appearance and the wonderful gardening talents of the Italian and Polish residents. Today in several towns varieties of peppers grow beside the hollyhocks.

A gardening phenomenon is Zachre and Elma Ascenzi Finelli's informally formal garden, in the center of Elkland's business section, with riotous purple clematis climbing over antique arbors, accented with coral colored azaleas, geraniums, impatiens, each in season, framing a modified Greek Revival house in rosy beige. Occasional topiaries, wrought iron accents with antique statuary among the rose beds and ivies, a drive with the tiles laid in patterns and a beautifully restored "in-town-barn" makes for a garden to translate one into Italy.

Galeton is Elkland's sister town, exuding Italian warmth. Many families in the two towns, 25 miles apart, are related. In both towns, former Italian grocery stores have become supermarkets; they are still the sources for gardiniera, Italian seasonings, in-house specialty meats and many varieties of pasta–just as they were 50 years ago, when the clientele was primarily Italian.

Many Italians from the region have achieved notably. Mike Crosetto, a bilingual Galeton native, had diplomatic skills honed as one of the first Department of Labor investigators into sweatshops in the 1930s. Serving in Italy in World War II, he was appointed liaison between the American Army and the Vatican at the end of the fighting. Mike became Chairman of the Pennsylvania Board of Labor Relations in the 1950s and 60s.

Discrimination still existed. Jack Fiorini, a retired educator, attributes to school consolidation in Sulli-

van County twenty years ago the breakdown of old ethnic prejudices: "When the kids started intermarrying, then things began to change." Many suggest the success of the Sullivan County consolidation of highly disparate communities in a sparsely populated terrain was made possible by Jack's amazing people-ability.

Mr. Fiorini tells how names were used to parcel out status. "In the mines the foremen were Welsh or Irish; the people who went down into the pits were Italians, Poles and Slovaks. Name changes arose from the bosses' inability to cope with a second language. The Coeli (Chae lee) family, the word for 'sky' for goodness' sake, became 'Kelly.'"[11] In some places, names were better maintained, thanks to the company clerks.

Slavic

The English, German and Scotch-Irish residents often included all eastern European immigrants under the broad folk category of "Polish." Elkland and the coal mining area around Blossburg in southern Tioga County, Clinton County and eastern Sullivan County still have significant Polish/Slavic populations. In some cases one can distinguish the country of origin, and in some, not.

Despite difficulty in transliterating phonetic characteristics of Polish and other eastern European names, some communities retain difficult names with relatively unchanged pronunciation. In Blossburg, Bogaczyks, Kurzejewskis, and Zuchowskis abound.

A surviving influence in virtually all the towns ever populated by Polish, Slovak, Hungarian, Russian families is the food—pierogies, stuffed cabbage, kolatschi. And it's not unheard of to detect someone cussing in Polish. Eastern European holiday customs are observed in a few households, and until recently, Blossburg, a town of under 2,000, supported two

Roman Catholic churches, the Polish and the "other" one.

Tiny towns near Blossburg exhibit proportionately dominant Eastern European influences in their town "plan." A "main street" winds along a hillside. The surrounding woods are largely incorporated into the towns, there is no grid pattern discernable, and the streets wander from house to house as though following footpaths. Driving down the mountain into tiny Lopez in eastern Sullivan County, one sustains a charming jolt: two beautifully kept small churches with eastern domes on the hillsides. St. Vladimir's Russian Orthodox Church and St. Peter and Paul's Byzantine Catholic Church are both finished with white wooden siding, surmounted with the beautiful domes and Eastern Cross with its second lower angled cross bar. Across the street from St. Peter and Paul's is a small, unpainted wooden shed, in perfect repair, a well-worn Pennsylvania Dutch hex sign appended.

Part of the "melting pot" syndrome occurred for these Slavic people in Europe and part in the United States. With the changing boundaries of countries in Europe throughout their history, there is considerable flexibility in language if not entirely in ethnic tolerance. Communication in the United States between the various ethnic groups required careful accommodation; over time it often promoted tolerance of "ethnicity."

German

Germania is the north country center of the mid-19th century German immigration to Pennsylvania. Besides responding to the direct appeal of a German town in a region named "the Black Forest," a number of Germans came to nearby Oleona, site of the Ole Bull Norwegian settlement, and then moved a few miles north to find perhaps a more "gemütlich" environment. Here music, food and architecture indicate

Mr. and Mrs. John Hajdu came to the United States from Hungary in the 1880s with their two teen-age daughters.

the strong German influence. Elders in the community recall attending the German language one-room school.

St. Vladimir's Russian Orthodox Church, Lopez.

Historical Sketches of Potter County contains an image of Germania in its heyday:

"The Social life of the colony followed the German tradition. On Sunday mornings the family attended church services. In the afternoon all would repair to one of the breweries with inns and dance halls in

Patricia M. Macneal

St. Peter and Paul's Byzantine Catholic Church, Lopez

connection. The older folks would sit around the tables and talk while sipping their beer and the younger generation danced ... [A "Schützen Verein" was organized in 1894 with a park and outdoor bowling alleys ... On Sundays] beer was not sold but Germa-

nia got beer by the simple expedience of having each member pay 25 cents as an attendance fee ... Germania's two bands, the Schoendorfer and the Schwarzenbach, performed on many occasions. Dancing was always important as were picnics and suppers."[12]

John Scholl, who had come to Pennsylvania as a coalminer in 1853, retired to Germania and pursued his craft as a wood carver. He died in 1916, locally revered as a great craftsman; fifty years later when some of his stored work was sold to a Folk Art Gallery in Stony Point, N. Y., he was all at once nationally recognized as a great artist. There was an exhibit of his work at Willard's Gallery in Manhattan in 1967, and he was featured in the December 1968 issue of *American Heritage* magazine.[13]

His woodworking tools are proudly displayed in the St. Matthaeus Lutheran Church in Germania.

Norwegian

Norwegians were among the immigrants who came to northern Pennsylvania to escape upheaval in Europe in the last century. Ole Bull's dramatic and ill-fated colony, described elsewhere in this book,[14] seems to have been the major settlement here of Norwegians. When the colony failed, most settlers moved west to Wisconsin and Minnesota.[15] "Three families: the Joergs, the Andresens and the Olsons refused to forsake the valley of Kettle Creek and remained to accomplish the purpose for which they had become settlers."[16]

Irish

Many Irish coming to the Northern Tier throughout the middle of the last century were first employed in the mines or with the railroads. Irish Settlement in Potter County was claimed to be exclusively "emerald" in the beginning. The founder, Martin Moran, came to Wellsville upon landing in New York in 1840.

When railroad work was slow in coming, he bought land in Genesee township and began a farm. In the spring of 1842 he was joined by several other settlers. Folklore says that none had more than $50 in their pockets, but they prevailed. In 1850 they built the first church in Potter County.[17]

Irish workers acclimated particularly well to the United States, probably partly because of language skills. They soon became foremen in the mines and mills. With Irish and Scotch-Irish so strongly established among original settlers, they "melted" easily into the cultural background.

Swedish

There are place name references to Swedish settlement in the Northern Tier with nary a Swede there today: Sweden Hill and Sweden Valley in Potter County, for instance. There are many Swedish people in the region, however, many of whom worked in the mines and in the tanneries. Like the Irish, they assimilated easily, and there is not a strong awareness of a discrete culture.

The town of Arnot in Bloss Township is two miles from strongly Polish/Slavic Blossburg. One would expect Arnot to be similar, but of the 750 names listed in a 1908-1909 Tioga County directory, 190 (one fourth) are Scandinavian, including 17 Andersons, 17 Ericksons, 27 Johnsons, and 12 Olsons.[18]

Factory and mining towns today reveal several Swedish names. And then there are the Christmas cookies. Swedish cookies are no surprise; they taste just like those the Blossburg ladies bring to share.

Swiss

The Heck family of Renovo and North Bend is descended from a Swiss family who settled in Swissdale, a 19th century community near Lock Haven that still exists in name. The Hecks say that no significantly

Swiss folk traditions survive in their family.[19] Their similarity to another, more dominant, local tradition with a common language, German, may have caused a blurring of any uniquely Swiss identification.

The terrain of North Bend, in the mountains at the sweep of the river, would suggest that a Swiss settler could eaily have been drawn there with thoughts of Switzerland.

French

Early French trappers came into both the southern and northern parts of the region, giving "modified French" place names to certain areas and towns and then moving on. Clinton County's Mackeyville, Booneville, and Eastville are examples, along with Duboistown, French Town, and Logue Hill in Lycoming County. It was the Frenchman Generet (Jondray) whose cabin gave Shinglehouse its name, and Sullivan County's Scout and 4-H Camp Brule was named for Champlain's scout, Etienne Brule, who traced the north branch of the Susquehanna in 1615-1616.[20] Most of these early French trappers and settlers did not stay long.

The most dramatic French settlement was Azilum in Bradford County at the end of the 18th century. The story is told elsewhere in the book.[21] After the establishment of a stable government in France, following the Revolution, emigres were encouraged to return, and many from Azilum did so. Life in the colony had been extremely difficult for people who had been born aristocrats. The French influence in the area seemed beneficial. A planned community with carefully constructed roads, window glass and other amenities imported from Philadelphia, and gentility in dealing with one another left a sense of civility that was broadly influential.[22] A few people stayed. Young Josh Homet, a descendant, can tell stories about his heri-

tage. He's eleven now, and has heard them from his grandfather.[23]

Laporte was named for a Frenchman. Some sources claim Laporte was the person who smuggled M. Talon, the founder of Azilum, out of France in an empty winecask. Others, perhaps more cynical, suggest that the town is named for the Laporte who was Secretary of Pennsylvania at the time of the founding. Dushore definitely was named for Aristide du petit Thouars, many years after the Frenchman left his log cabin in Sullivan County and returned to France to become a hero in the Napoleonic Navy, dying at the Battle of the Nile.[24]

Riding along the roads of Sullivan County, one is struck with the frequency of the name "Molyneux." You find that the first Molyneux settled in Millview, near Laporte, in 1794, absolutely contemporary with the Azilum years, and you say, "Yes! There has to be a connection!" You hear that there are 500 Molyneux descendants in Sullivan County alone, and that Louise Molyneux Woodhead is the person who understands the genealogy inside out. Louise explains: "Yes, it's originally a French name, but you note we have the English spelling with no *a*. The first Molyneux arrived in England with William the Conqueror in 1066."[25]

Welsh

Though names be deceptive, Welsh Settlement in Tioga County was settled by the Welsh. The extended Bowen family have recently reestablished visiting relationships with Wales. Jeanne Bowen says she does not think in terms of Welsh tradition in the family except for cookie recipes. And then she promptly adds how good they are with a nice pot of tea.[26]

The "first families" of Wellsboro in the first decade of the 19th century were of Welsh descent: the Mor-

rises and the Wells.[27] Since then there have been immigration surges that paralleled those of the Irish. Coal-mining families from Wales became settled in the coal towns in all the Northern Tier. Jones, Watkins, Gillespie, Vaughan, Williams, Pym, Evans, Lloyd, Llewellyn, Davies, Edwards, Owen are all common names. At the turn of the century they were farmers, merchants and miners.

African American

White people in the Northern Tier say that there has been no discrimination here; as an example you will be told about a black person from the community who was extraordinarily talented and successful.

The claim of no discrimination is not true, but it is a tribute to the achievers that they will say the same thing. Mamie Diggs of Williamsport is one of them. She says she realizes discrimination exists, but claims she has never suffered from it personally.

Mrs. Diggs' great grandfather, Daniel Hughes, was a Mohawk chief, possibly half-African, who has been documented as "engineer" in the escape of over 1,000 slaves through the Underground Railroad, with the help of his 16 children. A documentary filmed in Lycoming County during the summer of 1996 and scheduled to be featured on public television during December, 1996, "Follow the North Star," is the story of Hughes, based on years of research by his great granddaughter. Mrs. Diggs is under contract to write the book, by the same name, including all her research, for Temple University in 1997.[28]

A former corpsman in the Navy, Mrs. Diggs is a popular speaker in schools and colleges of the Northern Tier, where she tells the regional story of the Underground Railroad. She emphasizes that the goodness and bravery of people is color blind, and underlines for students the importance of education

and achievement. "You are on a ladder in your life. It doesn't matter if you are on the very lowest rung. You can go just as far as you can climb. Get a library card and an education."

Amish

In the 1970's Amish families from Lancaster County moved into southern Clinton County to escape from overcrowding and commercialization of their culture. They are respected for their mixture of conservative and advanced farming technologies, their business acumen, and their traditional crafts and trades, which include quilting, furniture making, harness making, baking, gardening, the growing of nursery stock, truck farming.

In the successive decades, a similar pattern has occurred in northwestern Tioga County as well, where local farmers are much impressed with the spirit infused into agribusiness by methods that may bring a new appreciation and revival of traditional lore.

A Look at the Future

Yet to be seen is whether television, the lack of job opportunities for young people, and prejudices which encourage the abandonment of ethnic cultural patterns will prevail. "Reenactments" are a far cry from living traditional culture. A folk culture thrives when people are proud of who they are, and are glad to pass on within the family and community those values and ways of doing things that have stood them in good stead through many years.

Overheard at a summer 1996 school reunion was a spirited conversation about Emil Caffo's peppers. Emil died in 1993. Attempted reconstruction of his pepper recipe goes on. His daughter Sally Schamel assured reminiscing imitators, "You know, he slipped other things in there he may not have told you–honey, for instance."

"There's no honey in the recipe he gave me! It says to start with a bushel of peppers. Do you suppose that's the secret?" (Laughter around.)

And the conversation goes on as it does in all next-generation-appreciation of family tradition. Swedish-German-English Jean Laughner Snyder, born in the very southwest of the region, and her "mostly German" northeastern Bradford County husband Austin live in suburban Philadelphia and work on keeping alive a delicious Italian tradition that Jean adopted with her high school friendships in Tioga County.

When Jeanie serves her version of this treasured dish to her grandchildren, they will still be "Emil's peppers."

Perhaps that's the best thing of all. Knowing about and understanding one's family past is recognized as being very affirming for the development of a strong sense of self. But appreciation and love for other families' values and traditions lends a warmth that is the difference between holding close a beautiful patchwork square of one's own design and snuggling under a patchwork quilt with squares from everyone, put together and quilted by the whole community.

Chapter 5

The Northern Tier Today

by Bonelyn L. Kyofski and Patricia M. Macneal

Time Passing

Today becomes yesterday and tomorrow becomes today in a way that is objectively orderly, but subjectively often chaotic, hard to grasp, and mysterious. History and folklore, memories, stories, hopes and plans are a few tools for coming to grips with the way time unfolds.

Our sense of time varies with our stage of life. Five year olds hear parents talking about the decade past and consider it grown-up talk about the long ago. Young people in the years of personality development and slow separation from their birth families, regard "today" as peculiarly their own. The eagerness and energy of that age bestows blindness to vulnerability and lack of experience. Later, when identity, family, and career are established, there comes a moment of realization — "I am as old as my parents!" You remember your parents doing what you are doing, being "young" as you are "young."

Then comes a day when you realize that your personal contact with the world is "over a hundred years old!" You remember vividly your grandfather's description of his first job, or your great-grandmother's story about a treasure given to her as a child. These events, recreated in your mind by a person close to your childhood, are events of the same century that not long ago you casually regarded as "irrelevant" and "History!" Suddenly your grandparents' world impinges directly on your own, and you want to ask

them questions, to better discern who they were–and
who you are. But they are gone.

So what have they left for you? Some family stories,
a photograph album, a few letters . . . and the ways of
thinking and doing that they felt were important and
valuable enough that they taught it to your parents
and to you.

Each generation's sense of itself is shaped by his-
torical events–wars, the depression, the baby boom,
political upheaval, economic plenty. As we as an indi-
vidual, a region, or a country experience these events
they become peaks upon which gather our sense of
who we are and what our life is "about." Time itself
moves on, but those events loom within us, often
without our awareness. They are part of us.

In the same way, places where we grow up, where
we choose to live, or where we live over decades are
part of us. We develop in our minds a feeling for where
"home" is, who "our kind of people" are, and where
"our part of the country" is. Our feelings about the
places where we belong can be extremely strong,
usually positive, sometimes not.

So, what are the details of life here today that we
give to the stranger or leave as legacy to children and
grandchildren?

Today in the Northern Tier

The stranger who first comes to this area might
arrive in Williamsport: a city, the 16th largest in Penn-
sylvania, with tree-lined residential streets, some strik-
ing old brownstones, older commercial buildings,
modern buildings, varying degrees of apparent pros-
perity. There are the usual strips and shopping malls.
Williamsport appears to be neither the Frontier nor the
Lumber Capital of the World.

It is the same with the rural areas. If you drive from
Williamsport to Emporium or Coudersport, you see a

hundred fifty miles of trees, punctuated first with views of the Susquehanna River and then occassional glimpses of meandering villages, and streams coming down valley from the tree covered slopes. If you like trees, you will be entranced. Otherwise, you might dismiss the terrain as emptiness.

The Northern Tier does not instantly offer its charms to strangers. Lying equally distant from Philadelphia and Pittsburg, it is accustomed to being the *terra incognita* within the modern urban mental framework of Pennsylvania geography. On early Pennsylvania maps, the entire Northland is labeled "Endless Mountains," and residents enjoy that image of their land.

People describe the Northern Tier as being "north of Interstate 80, in the central part of the state," or as being that part of Pennsylvania drained by the Genesee, the far reaches of the Susquehanna and the infant Allegheny. Even the people who live here debate where the boundaries are. To the west is the Oil Region; to the east, the eastern Endless Mountains and the Poconos. South is Central Pennsylvania. Philadelphia and Pittsburgh are far away.

In *The Atlas of Pennsylvania,* the map showing "Major Retail Shopping Centers in 1987" has such a large blank spot across the Northern Tier the editors placed the legend there. In the small towns, locally owned restaurants are easier to find than fast food franchises. In many valleys it is difficult to get any radio station or network television clearly because of the mountains.

In short, the Northern Tier is sparsely populated and isolated. One effect of under 50 people per square mile has been that people depend upon themselves for much that urban people expect to be provided to them. The depression of the 1980's caused increased incidence of an already chronic out-migration of young people, but also brought in retirees from

other parts of Pennsylvania, New Jersey, and Ohio, looking for a safe and inexpensive place to live.

Suchismita Sen, a folklorist from Calcutta, wrote of her impressions of Wellsboro, Tioga county: "I was struck by the quaint beauty of the town. It seemed to me that this town has somehow escaped the urban developments and industrializations that plagued the rest of the nation during the last couple of decades. It managed to hold on to the innocent spirit of the fifties and exuded a sense of comfort and security not usually found in other parts of this country. . . . The primary roadway that connects Wellsboro with Interstate 80, a main artery of Pennsylvania highways, is the beautiful and winding state route 287. This sometimes narrow route goes right through the northern forests of silver birch, hemlock, and pines, taking the visitor straight into the heart of Wellsboro, where the main street is still lighted by gas lights."[1] Gas was discovered in the area in the early 1930s; the gas lights were installed on the boulevard as part of a Victorian restoration in the 1960s.

Demographics and the Economy

Population in Wellsboro, in fact throughout the region with the exception of Williamsport and Lycoming County, has remained remarkably stable in the past century. Williamsport and Lycoming have thrived, nearly doubling in population. One suggested reason is that Williamsport was able to diversify quickly after the lumber era was over. Transportation and a manufacturing labor force in place gave Williamsport flexibility upon which it wisely capitalized.

The economy in the rest of the region is not booming, nor is it in total decline. Extractive industries continue. The Lower Kittaning coal seam has not been totally worked out: some strip mining is done in Tioga and Sullivan Counties, with underground mines

John Fidelinger

Red oak, a valuable hardwood of the Northern Tier forest today.

further west. Since the 1930's gas exploration and production have taken place in Potter, Tioga, and Clinton Counties. When driving through the area, one sees buried pipeline routes going up mountain and down, in a straight, clear treeless path, with an occasional orange and white valve sticking up.

Manufacturing is still important. There are the powdered metal and carbon plants in Potter and Cameron counties; the paper mill in Lock Haven; Woolrich, internationally famous for coats and outdoor sports wear; small sewing factories, and plastics and furniture manufacturing scattered through the area. An automotive component division of Ward Manufacturing is expected to go into production in Tioga County by early 1997. Relatively few central banks exist, most located in Williamsport.

In the 1980's many of the county-seat towns were concerned about empty Main Street store-fronts. The words "Main Street Manager" and "diversification" arose frequently in the Chambers of Commerce and planning commissions. In the villages and on the outskirts of towns are many small entrepreneurial endeavors: beauty shops, body shops, craft shops, landscaping, taxidermy, copy services, furniture pro-

duction, small engine repair, gun shops, fly and tackle shops, roadside produce stands, restaurants, hotels, and bed and breakfasts.

Recently the service sector of the economy has grown faster than any other. This includes hospitals and higher educational institutions. Because of the low population density, there are not as many of these institutions as there would be in an equal land area elsewhere in Pennsylvania, which sometimes means a longer way to drive to a hospital or a more difficult commute to night classes.

Comprehensive health services such as North Penn/Laurel Health System, the Sayre's Guthrie Clinic and Danville's Geisinger serve this rural region well. The Laurel Health Comprehensive Program was cited by Mrs. Clinton's study of health service in 1993. With Williamsport's Divine Providence Hospital, Williamsport General Hospital, Troy Hospital, Cole Memorial Hospital in Coudersport, and the Robert Packer Hospital in Sayre there is a range of choice for health care.

Mansfield and Lock Haven Universities, formerly teachers colleges, are part of the Pennsylvania State System for Higher Education. Pennsylvania College of Technology, formerly Williamsport Area Community College, with a branch campus near Wellsboro, is now owned by Penn State University. Lycoming is the private college of the region. Because of the sparsity of population, each public higher education institution is "regional," although among the smallest in the state.

Perhaps due to the settlement from New England, being well-read is important. Williamsport and Lock Haven have the largest public libraries in the area, and Mansfield and Williamsport the largest college library holdings. More surprising are the many small local libraries which work closely together, particularly in Potter, Tioga, and Bradford Counties. Bradford

County Library has for 50 years had an active book-mobile visiting remote sites, beginning with the one-room schools which existed until nearly 1960. Founder Dawes Markwell and her successors have seen marked improvement in reading scores of rural children closely following the improved access to books.

Land Ownership

In trying to reconcile "The Lumber Capital of the World" with what we see today, we wonder "Where did all the money go?" In the last century, lumber companies and private lumber barons owned huge tracts of land, from which they cut off and sold the timber. And then what? Some money obviously went into the public buildings and the elegant houses on "Millionaires' Row." Some went into manufacturing and other types of businesses that are still in the area today. Some went to children, who moved away and invested in "Fortune 500 companies," headquartered in big cities elsewhere. Some is still in the hands of now elderly widows or their children, who live quietly in the area, or so they say.

And who owns the land? In 1920, the mountains were bare: "The Great Pennsylvania Desert". For 30 years Dr. Joseph T. Rothrock had urged the state to preserve its forest. Now the land without trees seemed worthless, and the state of Pennsylvania could buy denuded acreage at a minimum amount per acre. Under the leadership of the first professional national forester turned governor, Gifford Pinchot, the vision was developed of a system of public owner-ship, which included state forests, state parks, state game lands, and state natural areas. When Maurice Goddard became Secretary of Forests and Waters in 1954, he was able to bring those plans to final fruition. Today the map of the northern tier is colored green for

the forests. Elk, Susquehannock, Tioga, Tiadaghton, Sproul, and part of Bald Eagle and Wyoming State Forests lie within the Northern Tier. Each forest has a forestry staff, and the trees are thriving. Hundreds of miles of trails invite exploration and enjoyment.

Private land ownership is also very important for those who live here. Property is often passed down within families, and there is a love of even the rocky, poor farms and woodlands that is hard to explain to an urban person. People's sense of identity often hangs on that intimate relationship between a piece of land and their lifetime of living on it that no amount of access to public land will satisfy. The interior of the Northern Tier is isolated enough from cities that development pressure is not generally strongly felt. But on the edges the decision about whether to keep the family property intact or to sell it for a high price for development can be excruciating, tearing at the fabric of families and communities. "Second home" developments in forests where they once saw only an occasional cabin is a shock to those who have a strong sense of possession for all the region's land.

Displacement of families in Little Pine Valley, Clinton County, in the 1950s and in Tioga County in the 70s caused untold trauma for many who could not comprehend being separated from their land. Involuntary sale after decades of apprehension at often a limited price caused many families to feel victimized as well as lost.

The sense of "ownership" of the region is general. People who grew up hunting over certain mountains and fishing certain streams–for ginseng, woodcock, trout, or inner peace–regard them as their own, and feel a strong sense of a right to walk there. State forests and game lands provide a way to help satisfy this strong relationship to the land. But there are also vast tracts of private property. Until about the 1950's,

there was agreement that hunters and fisherman were a brotherhood of people who shared feelings about the woods. Not posting land was considered a good thing; most people did not; and the state game laws gave certain advantages to farmers who did not post land.

Now, however, there are huge tracts of land, thousands of acres, with the perimeters "posted" with colored signs every ten feet, announcing that this marks a property line, and that trespassers risk a fine of hundreds or thousands of dollars. Some individual landowners, often newcomers, see themselves as running a game preserve for profit. Some hunt clubs have existed since the 1910's and 20's; others are recent. The members of the clubs are usually from the same city, and see the club property as a place to relax, live informally, and enjoy hunting and fishing with friends on several weekends a year. Posting by clubs has become almost universal. There is frequently resentment on the part of those who live year-round in the area and who were used to roaming the woods freely.

The issue is as old in America as settlement itself, the same argument outlined in William Bradford's *Of Plimoth Plantation* between the English and the Indians in 1621. Woods-roaming "natives" have been educated by the woods that, like temples, they belong to everyone. But privacy and property are supreme American values.

The State Bureau of Forestry is working with private woodland owners to promote thinking in terms of ecologically sound management and sustainable sylviculture. Posting is talked over in detail at the local garage or post office, along with the economy and the weather.

People and Attitudes

We run risks in trying to describe or categorize the people with whom we live. Even with "objective" statistics, it is easy to misinterpret or distort attitudes and outlooks. When we give an instance or example that seems typical, others say it is an exception, and that anecdotal material is never proof. Yet, the people who live in the Northern Tier do seem to have some common characteristics which set them off, as well as various ways of looking at the world.

Almost everyone is of European stock. Hair color, height and build vary, but skin color shows a narrow range, so much so that some urban visitors have gotten the eerie feeling that half the population is hidden away somewhere. They miss the densely populated multiracial appearance that they feel is "normal" or "correct."

Attitudes toward work tend to be very positive. With pay scales low, holding two jobs is not rare. Laid off or retired, people usually do something active, fixing up their place, pursuing a hobby or volunteering. Most women work outside the home.

Statistics show that both marriage and divorce rates are higher here than in the rest of the state. *The Pennsylvania Atlas* suggests that this fact may be caused by people from New York State crossing the border to get married and divorced. Perhaps. The percentage of single women within the total female population is low, and most people own their homes. There is a relatively high rate of family abuse. Those who live here, while deploring the facts, suggest that isolation and the need to be independent are stressful. People need a rich emotional support system, internal or external, to thrive here.

Tourism is an increasingly important economic sector, and a warm and thoughtful welcome is usually extended to short term visitors. In certain areas the

visitors tend to have much higher incomes and different value systems than the local residents; occasionally there is a percieved disregard for local people. Often then the welcome is polite and superficially warm, but underneath the surface there is hurt and resentment.

Traditionally, the general population has been hesitant about taking newcomers into the community, expecting the newcomers to first adjust to local ways before they will be fully accepted. Since negative feelings are often not directly expressed, the newcomer may be oblivious to such feelings, assuming that these are people of few words. The adjustment period may take several years, but once the hurdles are passed, the newcomers are regarded warmly as a real part of the community, and their claiming of the culture as their own is seen as an endearing affirmation. By then, of course, the newcomers realize they are not the same as those native born, and that their understanding of the relationships and the detail of community history will probably always be off the mark. But times are changing. There is easier acceptance now than there once was.

The effect of the economic realities of the old lumber industry is still felt today in the way people in the Northern Tier get along together. The prosperity and prominence of Williamsport as a major lumber trading center led to a focus on that side of the industry by historians and residents of Lycoming county, and there was often a lack of attention to the headwaters country where the trees grew and to the people who cut them down and brought them out. In 1992 during the Northern Tier Documentation Project by the Heritage Affairs Commission, the problem of the imbalance of focus and the assumptions that went with it was very apparent. Community projects and planning for the future of the area today are affected by old

feelings of injustice dating back into the last century. Recognizing and reconciling some of those feelings may be needed for any fruitful future planning in the area.

Despite some very negative personal interactions and disparities, people in the Northern Tier today are on the whole warm, friendly, well educated, and hopeful about the future for the area. Cooperation among the churches and the service agencies, and sharing of local resources, augurs well for the future. In the little neighboring towns of Morris and Liberty the women of the United Methodist, Mennonite, Baptist, Roman Catholic, Independent Grace Bible Church (related to the Brethern Church), and the Lutherans get together every Tuesday for prayer and planning on how they can together make their community a better place for their children. That's an issue you'd get a unanimous vote on in the Northern Tier.

One more characteristic: this is an area full of artists and folk artists. The seven chapters which follow focus on one folk art being practiced today in each of the seven counties now involved in the Northern Tier Cultural Alliance. A "County overview" at the first of each chapter gives a broader view of the county where the artist or artists live. Each of the seven folk arts, as well as many others, are found throughout the whole region, not just in the county under consideration. These sketches give an up-close view of some of the traditional artists who call The Northern Tier their home.

Chapter 6

Lycoming County Overview

Lycoming County, located in northcentral Pennsylvania, is the largest county in the state. Ranking 26th in population, the county contains 52 municipalities: 42 Townships, nine Boroughs and the City of Williamsport, county seat and the region's major metropolitan center.

Formed on April 13, 1795, from Northumberland County, Lycoming County at that time covered approximately 12,000 square miles, stretching north to the New York border. It takes its name from the American Indian word Lycaumick, meaning Sandy Stream.

The region's first inhabitants, in the region at least 10,000 years ago, were the American Indians. European traders came later because of the area's furs and plentiful supply of game. Their reports attracted settlers of European and African descent, who arrived in 1769 after the French and Indian War when the region, known as the New Purchase, was acquired from the Iroquois and opened to settlement.

Early settlers made their living by farming. In the 1800s, lumbering became the dominant industry in the region. It was during the county's lumber era, especially from 1862 until 1894, that Williamsport grew from a borough of 1,615 people to a town of 16,030.

Construction of the Susquehanna Boom and the West Branch Canal made the growth of the industry possible. James Perkins had the idea for the boom, a series of rock-filled wooden cribs stationed in the river connected by a chain of floating logs. Lumber that was harvested upstream was stored in the boom until it could be taken to Williamsport sawmills. At the peak of the lumbering era, more than 30 sawmills lined the river in Williamsport, providing lumber that was shipped throughout the world.

During this time, lumber related industries flourished, including furniture factories, planing mills, door manufacturers, wood working machinery companies, sash, door, blind, frame and molding companies and picture frame manufacturers. Tanning, dependent on hemlock bark, continued well into the 20th century. Also attracted were metal industries, rubber manufacturing, and later, textile production.

By the early 20th century, county planners began to seek a wider economic base, and industry diversified, with the economy realizing a substantial spurt during the 1920s. Light manufacturing still serves as an economic base but service industries are growing as well. Recent migration to the area includes those moving from urban areas to escape city problems and to enjoy a less hurried existence. As always, Lycoming County continues to attract people of all ethnic backgrounds.

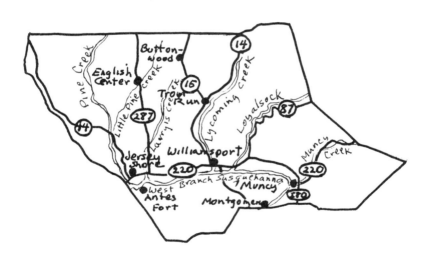

Lycoming County

The Craft of Rifle Making

by Sandra B. Rife

One of the earliest crafts of Lycoming County and indeed of any frontier area was the gunsmith's. According to the *History of Lycoming County,* written by John F. Meginness in 1892, one of the first gunsmiths in Lycoming County was Henry Gable, who operated a shop in Williamsport in the early 1800s. There were three other gunsmiths in the borough at that time and one who crafted guns in Muncy, a John P. Guyer. That this sparsely populated region had so many gunsmiths at once indicated the necessity of the craft.

The Gunsmith's Art

The early gunsmith was a master craftsman and, since he had to produce most rifle parts himself, he had to be a skilled worker in at least three materials — wood, iron, and brass or silver. He had to be skilled in forging, or at least rifling and finishing iron barrels, in making and carving wooden stocks and in casting and engraving brass or silver mounts.

Most gunsmiths in this area bought the barrel blanks from boring mills and used locks imported from Europe. They rifled the bore, however, and made the sights, finished the outside of the barrel, and made the trigger, trigger guard, butt plate, ramrod pipes, and nose cap. They planed the wooden stock blank (usually curly maple) and carved into it the channel for the barrel, the lock mortise, cheek piece, and patch box before further shaping, sanding and

staining it. They decorated the stock with brass or silver inlays of various designs. Since each rifle was custom made for the customer, each was different from all others.

A Modern Gunsmithing Family

Charles Gansell of Picture Rocks, a rural town southeast of Williamsport, practices the craft of gunsmithing, continuing an avocation practiced many years by his father Louis. Louis Edward Gansell was born in Proctor in a lumber camp where his father worked as a harness maker and his mother, Mary Gansell, worked as a cook. Louis became interested in crafting muzzle loaders when he was still a youth. It happened as a result of a fire that destroyed his home in 1898, when he was only five, burning the stocks on a collection of guns owned by his grandfather, Joseph Meracle, a Civil War veteran. Several years later, Louis began to restore the stocks and taught himself the craft of gunsmithing.

Charles Gansell was born in 1930 and became involved with the craft when he was only fifteen. At that time, his father, who worked as a wood carver, was injured and while recuperating decided to stay employed by fashioning army rifles into sporting rifles. Because the elder Gansell had difficulty doing the carving and inletting, he employed his son to do it. At first, Charles could not be given credit for this work because his father feared potential buyers might not consider them professionally made, given Charles' young age. After many comments on the excellence of the inletting and carving, the younger Gansell was recognized.

Louis and Charles made rifles for Harders in Williamsport and three other companies. When Louis returned to work in furniture manufacturing he continued to produce muzzle loaders at the home shop.

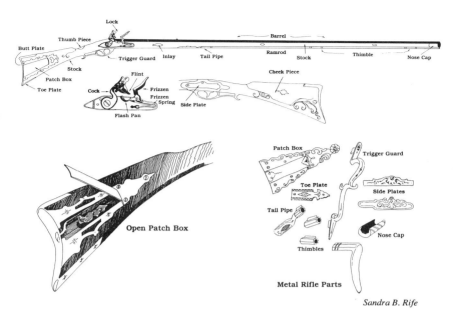

Diagram of gun and gun parts

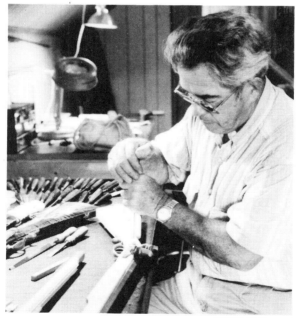

Patricia M. Macneal

Charles Gansell's work in progress.

Today, Charles continues the craft, enjoying the fascinating challenge of making a beautiful gun, and building it as it would have been crafted in an earlier time. He takes pride in creating and autographing them.

Gansell finds the craft not without its difficulties. Procuring wood for a Pennsylvania rifle is an art in itself, since he only uses curly maple because of its beauty and because, traditionally, it was the wood of choice. Additionally, the craft is unforgiving for if the gunsmith makes a mistake, he has to begin all over again. "For instance," Gansell states, "in drilling the ram rod holes, the channel has to be straight and true. If it wanders, you have ruined it, so you must do it an inch at a time."

To produce his guns, Gansell uses antique hand tools and makes many others of his own, including engravers. He does buy the ignition system and the rifled barrel but creates the stock from a plank rather than from a pre-shaped blank. When using hand planes, Gansell comments, "you have to cut in both directions continuously on curly maple." In addition to planes, saws, chisels for carving, and engravers, he uses the rasp, file and sand paper for finishing. "I probably use a hundred different tools to complete a gun," he says.

And it is all done for the love of the craft, for he finds there is no real profit in gunsmithing. Gansell also believes all hunters should use muzzle loaders, because it would require one true shot and thereby make hunting a skill.

Bradford County Overview

Bradford County, named in honor of William Bradford, the first Attorney General of the United States, stretches 40 miles north to south and 32 miles wide. It is the third largest county in the state. The straight boundary lines create an almost perfect parallelogram, which is bisected by the Chemung and North Branch of the Susquehanna. The central part is agricultural, with wide valleys and rolling hills. To the west, Armenia Mountain is shared with neighboring Tioga County. On the south, next to Sullivan County, is a high forested plateau, primarily State Game Lands. Highway 220 snakes its way north from the Sullivan county border through Towanda, the county seat situated on the North Branch, up to Sayre, on the New York State border.

By the year 1790 over two hundred families had settled in Bradford County. Many came from New England, attracted by descriptions of the "wondrous beauty and fertility" of this portion of the Allegheny Plateau.

Many of the towns in Bradford County are known for architecturally outstanding old buildings. The Bradford County Historical Society is located at 21 Main Street, Towanda, in a house built in approximately 1854 by James Macfarlane, a native of Gettysburg who came to Towanda in 1837 to work on the North Branch Canal in the capacity of a civil engineer, and whose family became prominent in the development of Towanda. In Rome the P. P. Bliss

Gospel Songwriters Museum preserves the home and various artifacts of the man who wrote "Wonderful Words of Life" and hundreds of other Gospel Hymns. On the edge of Troy in the northwest corner of the county is Alparon Park, the location for the Farm Museum and the site of the oldest annual agricultural fair in the state, first held in 1875.

This is a border county, which has joined with Sullivan, Susquehanna and Wyoming counties to form the Endless Mountains Heritage Trails, an organization aimed at presenting a series of regional events and places to visit.

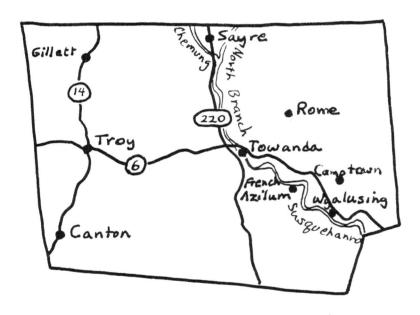

Bradford County

Spinning and Weaving in Bradford County

by Sylvia Wilson

During the pioneering era of the late 1700's, women's work was "never done," as the old rhyme says. Women carried water from a spring, cooked daily meals, milked a family cow, made gardens, butter and cheese, preserved or dried fruits and performed many arduous tasks related to homelife, which included spinning and weaving. Nearly every family grew a patch of the flax plant, used for making linen thread to be woven into clothing, towels, table-cloths and sheets. There was often also a patch of hemp for twine, carpet yarn, cordage, coarse bedding and storage sacks. About one acre was enough to supply the needs of a household.

The ability of a family to produce fabrics for its own use was helpful, but it was also extremely time-consuming, tedious and painstaking work. Starting with a patch of flax and a sheep, and ending up with a linsey-woolsey Sunday dress, made from a blend of very fine linen and wool, required extreme patience, a great many skills, and knowledge about the various stages of production. Throughout the Appalachians during the late 18th and early 19th century summer visitors would describe the sound of the beating of the loom on the front porch as they approached a house. With the Industrial Revolution and the use of commercial looms, spinning and weaving were rapidly given up by households that could afford to buy fabric. Only those who had more time than money, or those who really loved the craft kept it up.

Today there are less than 30 known spinners and weavers practicing the craft in Bradford County. Of those, Patricia Pomeroy Smith is the only known descendant of a Bradford County spinner.

Pat tells the story that in 1818 Isaac N. and Ebenezer Pomeroy, brothers, came from Connecticut to Troy and established a manufacturing plant for woolen cloth. Ebenezer was her great-great-grandfather. Her father, Daniel F. Pomeroy Jr., was Ebenezer's great-grandson. Born in Troy, Pat recalled a spinning wheel in the stairwell of the Pomeroy family home, but never saw it in use. Years later, the spinning wheel, a family heirloom, remained in the house then occupied by her aunt. Pat asked if she might have the wheel and learn to spin. No one in the family could teach her, but after studying books on the subject and observing productive spinners, she mastered the craft and has demonstrated her skill at Troy's annual Agricultural Fair in Alparon Park since 1986.

Patricia M. Macneal

Pat Pomeroy Smith helps her student Sharon Bennett of Towanda at the 1996 Troy Fair.

Spinning and weaving involve skills and knowledge in a wide range of distinct activities: growing and preparation of fibers, dying processes, and the use of spinning wheels and looms. We will consider each in turn, before again looking at those practicing the craft today.

From Flax to Linen Thread

Seed for flax was sown in early May and harvested in late July. Mature plants were then gathered into small bundles, tied, and allowed to dry for several days. When dry, the stalks were pulled apart and drawn through a coarse "ripple comb" to break off seed bolls. Unused portions of the seed were saved for future planting or sold. At the time of the first settlement in Bradford county, flax seed, used for linseed oil, was a major export from the port of Philadelphia.[1]

The next process involved tying and wetting the stalks of the plant, which were then spread out to rot, or "ret." This procedure allowed the fiber to soften. People today in their 90's who live on the Appalachian Plateau report remembering how their grandparents submerged the stalks in a stream for two weeks, but say it was not done much after World War I.[2]

When the rotted stalks were taken from the water, they were again raked, and tied into large bundles. The flax was broken with a flax brake, a rather large frame. The men did this. Next it was "scutched," or beaten with a knife against a board. The purpose was to remove an outer husk and inner core to get to the fine fibers.

A process called "hackling" or "hatcheling" followed, which involved pulling the fibers through long steel teeth, fixed in a board, separating the fibers according to length, firmness and quality. Further hackling was continued according to how fine a fiber

was sought. Securing the fiber finally on a distaff, a spool-like device, prepared it for spinning.

Heverly's *History and Geography of Bradford County* tells of a ninety year old woman, the wife of Nathan Northrup, residing in Athens village who, in 1786, had spun eighty knots of yarn in one day. Seven knots were considered a good day's work. Mrs. Northrup had been a native of Connecticut, which in 1640 had passed a law requiring every family to spin a certain amount of flax each year or pay a penalty. Heverly also refers to the first fire in the Towanda area occurring in 1798 when Frederick Eiklor, a settler from Catskill, New York, was dressing flax. (It might be noted that the flammability of "tow," the short fibres discarded in the hackling process, was famous, and it was sometimes used as a kindling for starting a fire.)

In 1775, Isaac Foster, a mechanic and native of Massachusetts, with his two sons Abial and Rufus, settled in Claverack, one of the original 17 townships in Bradford County, located in an area embracing half of Wysox and the Towandas in the lower Sheshequin area near a section of Macedonia. There, he established a shop, manufacturing spinning wheels to satisfy a demand for this important household item. Space on the flat boats or wagons used by the settler was at a premium. Isaac Foster knew that every family could not carry this precious and bulky item to their new home.

From Sheep to Yarn

Farmers kept a few sheep in the early settlement days, mainly to secure wool for clothing. Shearing was done in the spring, before the hot weather. The wool was processed for family use by hand carding, done with a set of boards covered with metal teeth. By stroking handfulls of wool back and forth across the

teeth, dirt was removed and the fibers combed smooth. History relates that wool carding machines were set up on Wyalusing Creek in 1807 and another at Milltown in 1809. Camptown, located five miles northeast of Wyalusing Borough had a woolen factory operating at that same time.[3]

Carding mills were a great boon to spinners in the area; they removed the vegetation, dust and debris

Bonelyn Kyofski

Kathleen England spinning in the shade of a lilac at the Tioga County Historical Society's Blockhouse, June 1995.

from shorn wool much more quickly, and prepared the wool for spinning. The spinning itself could be done on the same wheel as was used for flax, but the finished product was usually heavier, intended for winter use.

During the 1790's, farm women wore linsey wool-sey undergarments in summer and woolen ones in the winter. A good spinner could make a very fine linsey woolsey thread, an early "blend" that had the best qualities of both fibers.

Dyeing

Coloring hanks of yarn or fabric was a unique proc-ess and sometimes depended upon the innovation and creative ability of the individual. Wool would take on deep shades of the homemade dyes readily. The linen absorbed the color more slowly. It could be easily tinted, but would not give the deep vibrant colors of wool.

Shades of brown or black were secured from the walnut hull, gathered when the walnut fell from the trees in the fall of the year. The roots and bark of the tree were also used and the desired color tones oc-curred in boiling the substance. Darker shades were made by allowing the yarn or fabric to remain in the boiling water for a longer period of time. Gray moss taken from an oak or an apple tree produced the colors orange or yellow. Blue was produced by using indigo root. Maple bark was ground into a powder, and when boiled with the material, created shades of red. Poke berry roots made shades of purple and tones of green occurred when oak leaves were boiled. Once the fabric had been dyed to the desired color, the dye had to be "set" with salt or some other house-hold substance to make it colorfast.

True to their New England roots, the women prob-ably felt that the muted, or "sad" tones of mossy or

dark green, maroons, beiges and browns, and grey-blues were their favorite colors. They can be produced with natural dyes with wool and linen. Bright colors are more easily achieved with cotton and silk, colors and fabrics favored by women in early Virginia and further south.

This regional color preference seems to be still observable today. Around 1980 an arts administrator noticed that women in Pittsburgh, New York, and Boston tended to wear a very limited range of colors: forest green, maroon and beige. He had no explanation, but thought it was surprisingly consistent. Grey, black and white added to these colors are the elegant sad and sober colors of the Puritans and the Quakers. In contrast is an experience reported by the manager of a Pennsylvania quilters group. The quilters had great difficulty in selecting the type of bright colors that a shop in the Washington D.C. area said sold the best. To the Pennsylvanians, bright colors looked tacky. To the women in Virginia, muted and dark colors looked dull.[4]

From Then to Now

As with spinning and dyeing, weaving was first done in the home. But in the late 1790's in Bradford County, nearly every prosperous farmer and his wife possessed a few "store boughten" garments which were treasured and often willed to their children. In the next twenty years, traveling tailors and shoemakers visited the homes of rural patrons once or twice a year. Many farmers laid in a stock of leather to make shoes for their families, and wives could purchase a stock of homespun for sewing from a peddler passing through the area.

It was a common practice during this period for the housewife to barter homespun at the country store in exchange for spices, sugar, salt, tea and coffee. The

transfer of the textile industry from home to factory was gradual. In 1808 a fulling mill was built in Troy. The process, powered by a water wheel, turned and beat woven cloth until it reached the expected size, softness and pliancy. Ten years later, Pat Pomeroy Smith's great-great grandfather built the woolen mill in Troy. By 1830, the shelves of most country stores carried factory produced linens, cottons and woolens, driving homespun from the marketplace. Spinning wheels in the home were heard less frequently.

By 1900 the pastime or hobby of spinning and weaving replaced the necessity of practicing the craft. The coverlet, particularly rare and beautiful, expressing technique, design and color noting distinguishing cultural and regional differences in design, now appears in museums or remains a prized family possession. Many of these coverlets were woven by professional weavers, generally men. The woven signature inscribed in a coverlet with a date or initial of the weaver is particularly valuable and rare.

Modern Spinners of Bradford County

Bill Ralph and his wife Victoria, formerly from Merrick, Long Island, New York, presently living in Orwell, are considered experts in the art of spinning and weaving. Their craft was the result of Bill's expertise in repairing old wheels found in attics and the market place. His curiosity about the wheel led him to its use. His wife soon followed his interest, and currently they are occupied in giving demonstrations around the state, helping the novice improve her craft and repairing wheels and looms.

In 1996 Eva N. Herrington of Wyalusing told the story of how she learned to spin:

"In my Grandmother's high attic in her Connecticut home, there were yarn winders and a bobbin winder

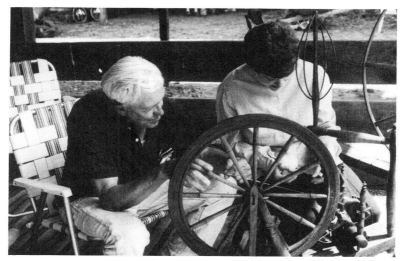

Patricia M. Macneal

*Bill Ralph explains the working of an antique wheel to Catherine
Laubach of Hughesville.*

wheel. They were always a part of my childhood
memories, even if they weren't really understood. The
knowledge of what they were and how long they had
been in the family came when two of my aunts be-
came interested in antiques when I was in my teens.

"My Uncle Ray made a spinning wheel for my Aunt
Audrey because she had become interested in hand-
spinning. I watched in fascination as she spun wool
fleece to yarn. I knew that she gave demonstrations at
her local County Fair in Connecticut, although I never
had the pleasure of seeing her do it.

"My husband Steve and I moved to Pennsylvania
and after the birth of our third child, my Aunt Audrey
gave me her wheel because she knew that I was trying
to learn how to spin. My cousin Laurie and I started to
learn at the same time by reading books and with a lot
of phone calls to each other.

"I found that spinning filled that need in me to be
creative, as well as quieting my mind and relieving

stress. It was hard to be upset when I'm doing something I love so much!

"I really became a proficient spinner after I joined others in Bradford County to organize the 'Cat's Cradle Handspinning Guild'. Together, we have shared techniques, problems, solutions and a love of this ancient craft.

"I feel that my spinning ties me not only to the new traditions of my family as I pass my Aunt's craft on to my daughter, my sister and her daughter, but also to my family's past. Now, with my guild, I also demonstrate handspinning at fairs, craft shows, and at our local historical site, French Asylum. I don't know who used the yarn winders and bobbin winder wheel now in the loft in my house, but I feel a closeness to the women in my family who have passed on, as I create something practical and beautiful."

Pennsylvania museums devoted to spinning and weaving are in "Old Economy", the final home of the Harmony Society near Ambridge, close to Pittsburgh, and the Landis Valley Farm Museum in Lancaster.[5]

Spinning and weaving will never become a lost art as long as its magic continues to entice. Although the Industrial Revolution made machine-made and imported goods widely available, the appreciation of handmade and homemade items will always remain.

Clinton County Overview

Clinton County, originally to be named Bald Eagle County, was at first part of Northumberland County. Through a quirk of fate, it was finally named Clinton after the Governor of New York.

Many ethnic groups of people settled in Clinton County during the mid 1800s: Italians, Germans, Slovaks, English, Nova Scotians and French. They settled here for religious freedom and to find employment during the construction of the West Branch Canal, in the logging and lumber industry, the railroads, woolen mills, coal and clay mines, iron works and construction trades. Many purchased land, farmed, raised families and became part of Clinton County.

The giant lumber industry that once supplied pine spars and masts to shipyards and hemlock bark to tanneries is now principally supplying select hardwoods to furniture manufacturers in places like Japan and Belgium, as well as locally. The railroads have curtailed operations and closed what was the largest railroad repair shop, in Renovo. Brickyards, coal and clay mines are today no longer producing as they once did in Clinton County. The Woolrich woolen mill is still in operation, but Piper Aircraft Corporation, at one time the world's largest producer of small aircraft, formerly located in Lock Haven, Clinton County, is now closed. Today the two largest employers in the county are the Hammermill Paper Company and the Lock Haven University, plus many small family owned businesses.

The two greatest industries in the county today are agriculture, seen along the Susquehanna River plains and valleys, including dairy, vegetable, and grain farming; and the development of recreation as offered through the vast acreage of forest lands, which includes hunting, fishing, hiking, camping, boating, skiing, snowmobiling, and other leasure activities.

The end result of this progress over the years is that Clinton County has its share of ethnic folklore and folk artists, including weavers, spinners, wood carvers, blacksmiths, basket makers, storytellers, potters and musicians, with many more folks who just enjoy keeping family crafts and traditions alive.

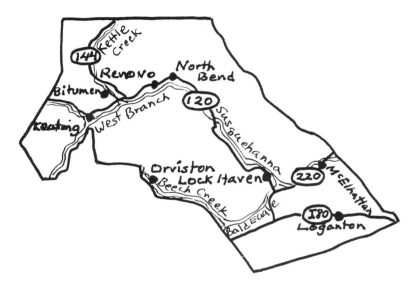

Clinton County

A Look at Three Faces: Musical Tradition in Clinton County

by Douglas Manger

Within this century we have seen a shift away from policies promoting a national identity toward ones striving for more awareness and appreciation of our diverse cultures.[1] As a consequence of this shift, a multitude of federal, state, and independent agencies sprang up to promote the concept of cultural conservation, and to identify, conserve, and promote the varied cultural traditions within the nation.

In due time, with the help of the Pennsylvania Heritage Affairs Commission and references from Dr. Ken Thigpen, project director of the Northern Tier Documentation Project, I traveled to Lock Haven in the summer of 1992 to set up a field office as a folklore researcher. My first initiative was to locate traditional musicians in Clinton and the adjoining counties. The following narrative reveals three personalities within this working area who have been instrumental in either promoting or carrying forth the region's traditional strands of music.

John LaRose — the Promotor

It was with a slight feeling of apprehension that I dialed John LaRose in Lock Haven. My insecurity proved pointless as John was open and anxious to share his knowledge of the musical scene in the Clinton county area. After a lengthy introduction, we agreed to meet the next night at his home for a taped interview.

A short, stocky man with an easy laugh and hair done up in a ponytail, John resembled more a Rock musician out of the 1960s than an aficionado of local Bluegrass music. Three hours of conversation later proved me wrong. Although originally from the Reading area, John took to Lock Haven's Water Street and the neighboring mountains like a native. While a student at Lock Haven University (1970–74), John worked with Doug Stoner to form the Lock Haven Folk Song Society. The society's interest in presenting local, traditional performers in concert at the university led John to Jim Davy, a leading area Bluegrass musician who lived in neighboring Orviston.

When Jim Davy heard of John's plan for a concert, he was beside himself. Why would college students want to hear Bluegrass? But listen they did and John and many of his student friends, accustomed to popular Hard Rock music, found themselves hooked on the traditional strains of Bluegrass music.[2]

After college and a brief downstate stay in Reading, John returned to Lock Haven to establish a permanent home. Once again he encouraged the local music scene by hosting Saturday night gatherings in his home. This informal group of weekend "pickers" soon came to be known affectionately as the Bald Eagle Creek Kitchen Band. John would later remark, "[I have] never seen a town with so many musicians per capita...traditional, jazz, Rock and Roll, heavy metal, 'ol timey, Irish, Bluegrass, Italian..."

In 1977 John founded the Bald Eagle Folk Collective with $50.00 from his own pocket and the sale of membership cards. The money was used to bring folk singers to Lock Haven. Over an eight-year period national and regional artists such as Rosalie Sorrell, Utah Phillips, Jane Doss, and Norman and Nancy Blake performed at venues (wherever was cheap) in and around Lock Haven. But as avid as John was

Potter County Historical Society.

Characters from "The Whittle Band," carved by Leonard Treat.

about visiting folk revivalist artists, the gradual process of an outsider being won over by local traditional musicians continued.

John found music to be a common bond in the area that transcended religion, politics, and race. "Jim Davy got me sucked into 'ol timey banjo. I became genuinely interested in local culture and came to respect it." Local gigs gave John exposure to more musicians in the area—ol' time fiddler Cliff Merrifield and banjo/vocalist Joe Dietrich who played with Blaine Shover (fiddle), Craig Bowman (mandolin), Dale Haines (guitar), and Phil Reeder (stand-up bass).[3]

Gradually the organized concert scene wound down, but the ritualized weekend gatherings or "picking parties" remain as popular today as ever. John still finds the number of weekly picking parties in the area surprising. "It's [the gatherings] a lot more prominent than you'd expect for its size. Just the fact that this whole summer, almost every weekend, I could have spent playing music somewhere at a party."

Little did I realize that three nights later we would be at one such gathering—Smed's 12th Annual Summer Party—deep in the hills overlooking Jersey Shore. After we watched the fireworks with a yard full of excited guests and had our fill of eats around the campfire, the local music scene that John spoke so fondly about sprang to life. Out came well-worn fiddles, banjoes, mandolins and guitars, and suddenly the night air was filled with the strains of Mountain Music. Here it was, the strains of two centuries of musical tradition in the area ending up right here before us in the chilly night air at Smed's.

Jim Davy — The Player

Beech Creek shimmered through the trees as I made my way west up the hollow toward Orviston on Route 364. Jim greeted me in the yard, a slender man dressed in an open-neck shirt and casual pants. We sat on the sunporch within eyeshot of his son's home and eased into conversation about a life devoted to Bluegrass music.

Jim was raised three miles down the hollow in the town of Monument. During his boyhood days in the late 1940s and early 1950s, Jim passed the time listening to the Grand Ole Opry, Old Dominion Barn Dance and The Wheeling Jamboree on the family radio. A companion at the time, Dick Bowmaster, shared Jim's growing interest in music. Dick eventually bought a guitar and talked George "Fitz" Shady, a tenor banjo player living in Monument, into giving him a few lessons.[4] Jim followed Dick's lead and invested in his first instrument, a $19.95 Kay-Guitar. Their mutual interest in music sparked a friendship and soon the two boys began to practice together. The type of music they liked to imitate was called "Hillbilly" or "Mountain" music. In 1954, Jim and Dick decided to enter the Purple Whirl Talent Show at Lock

Haven High School dressed as hillbillies. They grew their hair long and on the night of the show took to stage dressed in dirty overalls with bare feet. The two numbers they played—the only two they knew—launched their career in music as the Ozark Mountain Boys.

Their routine, of course, was pure comedy. Any attempt to play hillbilly straight, a type of music most of the students considered "hick," would have led to instant ridicule. No matter, the act caught on and soon the Ozark Mountain Boys were playing the Kiwanis, Rotary, and Masons.

Every Saturday night Lock Haven residents could tune in WPBZ and listen to the Bald Eagle Valley Barn Dance broadcast from Hillbilly Haven just a few miles east of Beech Creek. Palmer Stover played the show with his group called The Trailblazers. Eventually Palmer got wind of the Ozark Mountain Boys and asked them to join the show and play alongside his Country and Western band.[5] Palmer wanted the two "hillbillies" to provide comic relief when the show hit a lull. The deal was soon struck and Jim and Dick took their act on the radio.

By the mid-1950s, Country and Western music had gained a solid following and the music (now increasingly electrified) of Hank Snow, Webb Pierce, Ernest Tubb, and Carl Smith could be heard nightly over the airwaves in the Lock Haven area.[6] Jim and Dick resisted the Country and Western influence, however, and stuck with Mountain music. By this time, Dick had added a fiddle to his repertoire, given to him by Milford Fetzer, and an eight dollar mandolin.

Certainly a major influence on the wiry Ozark Mountain Boys was the music dubbed "Bluegrass," played by Hack Johnson and the Tennesseans on the Old Dominion Barn Dance, beamed out of WRVA in Richmond, Virginia. This was exactly the type of music

they had been looking for. Not Hillbilly—but Blue-grass! This was the music of Bill Monroe, the founder of Bluegrass music, and the now renowned Lester Flatt and Earl Scruggs.

One weekend, Jim traveled to the popular Hillbilly Park in Williamsport to watch several bands perform on Bob and Dean's Radio Corral. The professional Bluegrass band that took the stage that evening looked nothing like the Country and Western bands Jim was accustomed to seeing. The players, dressed in plain white shirts with black ties, black trousers and white "buck" shoes, just sang and played straight ahead without the showbiz glitz so common at Country and Western performances. Jim took note of the composition of the band—a banjo player, guitar, fiddle, mandolin, and stand-up bass.

In 1956, Dick graduated from Williamsport Tech and hired on with the Worthington Corporation in Wellsville, New York. When it appeared the move would break up the Ozark Mountain Boys, Dick's creativity prevailed. He offered to teach the basics of drafting to Jim and then encouraged him to apply for an opening with Worthington. After an evening crash course, Jim interviewed and bluffed his way into the job. And so it was, the Ozark Mountain Boys remained intact and went on to play area square dances, minstrel shows at high schools and colleges, and the usual round of community clubs. At this time, Jim was still playing the guitar with Dick on the banjo and mandolin.

Round about 1957, Jim and Dick traveled to Middleburg, Pennsylvania, to see the Osborne Brothers. Impressed with a supporting act from Middleburg called the Kratzer Brothers, Jim and Dave headed back stage to talk up a possible partnership. Before the evening ended the two groups agreed to combine and form the Bluegrass Cut-Ups. The Cut-Ups played

fundraisers, bingo nights, volunteer fire departments, and other social events until 1959. In that year, Worthington Corporation began laying off employees and Jim was let go. The Bluegrass Cut-Ups dissolved and Jim returned to Pennsylvania and settled in the Lock Haven area.

Back home, Jim took up with Hank and Cook's Old Time Country Boys, a four-piece band that played local events and several live Saturday radio programs.[7] But the travel and weekend play got to be too much and Jim "kinda gave it up."

In 1965 the urge to play cropped up again. Jim had taken an interest in playing the five-string banjo and had purchased a much sought-after 1928 Gibson Granada Gold. The instrument fired Jim's interest and soon he formed another band called Jim Davy and the Sounds of Bluegrass.

Over the years Jim had taken the time to share his knowledge of "picking" with his son Steve. Equally as important, Jim had given Steve a thorough grounding in the history of Bluegrass. Now Steve was ready to take his place beside his dad on the guitar in the newly formed group. The Sounds of Bluegrass played festivals, schools, and universities within a 150 mile radius. Their bookings included Bluegrass festivals which usually ran from Thursday through Sunday.

All went well with the group until they started playing clubs and beer joints at the request of one of the band members. Jim and Steve didn't care for the noise and the crowds and eventually these bookings were dropped. By the mid-1980's, Jim Davy and the Sounds of Bluegrass had stopped playing gigs altogether.

Steve Davy has continued with his own band called Steve Davy and the Freelance. The four-piece group features Steve on guitar, Paul Carothers from Stormstown on the five-string banjo, Joe Harpster on

Jim Davy

Steve and Jim Davy, at their home in Orviston.

the mandolin from Bellefonte, and Jim Lomison of Jersey Shore on the upright bass.

<p style="text-align:center">***</p>

Jim paused and placed his hands behind his head. He had lived the changes in Bluegrass from a time of ridicule in the 1950's to its present-day acceptance in mainstream Country and Western music. He had seen the influence of Lester Flatt and Earl Scruggs, particularly their rendering of "Foggy Mountain Breakdown" for the movie soundtrack *Bonnie and Clyde*, which opened the door a "crack" to public acceptance. And their follow-up, the popular five-string banjo riff became the theme for the television series *Beverly Hillbillies.* And finally, the breakthrough, as Jim sees it, was the Don Reno/Arthur Smith composition "Dueling Banjos" for the movie soundtrack *Deliverance.*

Jim spoke with obvious pride of the growth in popu-

larity of Bluegrass, from the first festival in Fincastle, Virginia in 1964, to its inroads today into the very heart of Nashville Country music with former and current Bluegrass artists Ricky Skaggs, Vince Gill, Vern Gosdin, and Allison Krouse. "Bluegrass," he reiterated, "is its own type of music with its own harmony, timing, and instruments."

<center>***</center>

Why do some folk share a talent and others choose not to? It's a complex question with as many answers perhaps as people around us. For Jim, I suspect, it seemed a tradition too precious, indeed, too significant, to let die.

As we said our goodbyes, I felt gratified that Jim had not only lived and studied the Bluegrass tradition, but had taken the time to pass his knowledge onto the next generation to ensure that Bluegrass lives on in Pennsylvania.

Chester Wynn — the Handsman

Chester Wynn wears red-frame glasses—somewhat surprising on a senior citizen—but perfect in a way to accent his ready wit and white, scraggly beard. He and "the Mrs." live in Sugar Valley up Route 880 on the side of a mountain in a home they shaped largely themselves. The house seems just right, with low ceilings and comfortable overstuffed chairs within easy reach, and two dogs nearby to kick up a fuss when visitors drop by. This was a peaceful place at one time where one could watch the deer off the front porch. Now the persistent rumble of trucks on the Interstate up the hill has ruined the effect.

Vern Harbach and his wife met me at Peachy's Amish Market on the valley road and led me up to Chet's. Chet met us in overalls, gracious and reserved. I took a seat in silence, self-conscious about pushing too hard and fast for information. I knew

Chester was a player of sorts, but I didn't want to put him on the spot until we were comfortable with each other. Besides, he had just had heart surgery and looked pale and drawn.

Vern, however, had no such reservations and broke out his guitar and asked Chet to pick with him. I could see Chet was reluctant and self-conscious about a repertoire largely forgotten. But as Vern began to pick and sing, a spark came to Chet's eyes and a smile started to build. With a little more prodding Chet brought out a mandolin which looked handmade. I was skeptical at first about its quality until he started to play, then once again my preconceptions proved wrong. The strains of "Lamplighting Time in the Valley" under Chet's hand rolled out in tones every bit as good as those from a storebought instrument.

There were five of the Wynn kids who grew up in the backwoods on a farm in the Nippenose Valley. Chester opted out of school most of the time to help his dad farm a 115 acre plot. In the 1920s the family "grew their own eats" — oats, wheat, corn, potatoes, and assorted vegetables. Up at five in the morning to curry the horses and feed the cows, Chet took to handwork better than schooling and learned to make do for himself.

When farm prices dropped, Chester's father shut the farm down and set up a still for "makin' moonshine." The 150 proof alcohol was easy to sell. In fact, some customers weren't particular about the six-month aging process and drank it right from the still. Chester claims a local preacher was in the bootleg business, as well. He'd haul glass jugs of moonshine to town covered with the same apples time and again, but the "Feds" finally got wise and nabbed him.[8]

By fourteen or so Chet had quit school to start a work life that would span some fifty years–Piper Aircraft in Lock Haven, cutting timber in the woods,

seventeen years with the highway department, some carpentry, and then the last few years at the woolen mills in Woolrich.

It seems through it all music played a major role in Chester's life. "I just liked music ... seemed like I done it before." At around ten years of age, Chester fashioned a guitar and mandolin. Although the guitar was pretty much a failure, the mandolin had promise. "[I] took a headlight off an old automobile, an old Maxwell headlight, and I whittled the neck out, put it on, [and] got some strings. The metal body had the distinctive shape of a "goose egg" with a sound that suited the local folks just fine."

The Wynn family had no money for instruments or lessons so Chester learned what he could listening to WLS radio out of Chicago. He also took to watching the musicians who came out to the farm from Williamsport on Sundays "to holler, hoop, and yell." "They was musicians. They was good. They was playing guitars and banjos...country, western, mountain music...anything. They'd play 'em as they came out. I play now what they played then."

Chester would watch and listen to these musicians and then take up an instrument to play what he could. The music came easily and soon he could fiddle a tune after a few practice runs. "I never learned notes. [I] don't know one note from another." When Chester left the farm he continued playing and was soon called upon to play barn dances throughout the area.

<p style="text-align:center">***</p>

As we sit in the warmth of the woodshop, my eye is drawn to the simple, rough mahogany guitar in progress on the workbench. It makes me wonder about our present-day obsession with refinement and technique. Maybe Chester in his own way is urging us to just do in a simple fashion with fewer questions.

"Maybe I hear a song I like. I could just start off and play. [It] just comes to you like that. Music is something that you can't...you just don't understand. You can't...well, I don't know...it's there and that's it."

John LaRose urged our field team to stage a gathering to recognize those traditional musicians in the area who play simply for the love of playing. On Sunday, September 13, 1992, such a gathering was held on Craig Bowman's farm south of Lock Haven under the theme, "Generations: A Gathering of Ages." A film team from the Documentary Resource Center in Lemont, Pennsylvania, recorded the event for the Ross Library in Lock Haven and for the Pennsylvania Heritage Affairs Commission in Harrisburg. The musicians in attendance included Joe Bitner, Craig Bowman and his son, Kyle, Paul Caruthers, Jim Davy, Steve Davy, Joe Dietrich, Dale Haines, Joe Harpster, Charlie "Buck" Kramer, Cindy Kline, John LaRose, Kelsey Lomison, Lucy McLaughlin, Clifford ("Cliff") Merrifield, Leonard Parucha, Phil Reeder, Dennis Ricker, Claire Schrack, Blaine Shover, and Larry Wheeler.

Chapter 9

Tioga County Overview

An area across the Northern Tier of Pennsylvania is often referred to as "God's Country," undoubtedly a reference to the fact that forests and gamelands make up much of the sparsely populated landscape. Tioga County, almost square in form and containing about 1,150 square miles, fits that description. Bordered by New York State, Potter County, Bradford County, and Lycoming County (the county from which it was formed in 1804), Tioga County, like its neighbors, has always been heavily involved in forestry and agriculture.

Though Tioga County is the second largest county in the state, it has only about 41,000 inhabitants. Its flat-topped hills and steep valleys are characteristic of the Allegheny Plateau and probably served as a deterrrent to a rapid settlement.

Many of the factors that attracted settlers in the last two centuries are still present today–available land, beautiful scenery, rolling hills, game, and opportunities to fulfill the "pioneer spirit."

Drive through Tioga County's small towns and you will see in the center the "square" (park), a concept from Europe. White church steeples poke their heads up making you think you are in the New England States. In these small towns, and along the rural roads as well, are houses built in the Greek Revival tradition with wide board trim, shutters, columns and pilasters popular in the middle of the nineteenth century. Since World War II, and particularly after the the Bicentennial in 1976, increasing "pride of place" is evident.

Outdoor recreation areas are popular at Cowanesque, Tioga, Hammond, Nessmuk, Hills Creek and Beech Wood Lakes. Fishing in the spring and hunting for deer and turkey in the fall attract visitors. Pine Creek has recently been designated a "Scenic River," and a Rails-to-Trails program is being developed on the former railroad bed alongside the river.

In 1938 the Pennsylvania State Laurel Festival was conceived in Wellsboro, calling attention to our state flower, the Grand Canyon, and the Pine Creek Gorge, as well as talents of young Pennsylvanians. Like other Northern Tier counties, Tioga County has local fairs, historical festivals, reenactments, and other living history events that celebrate community effort and values.

The National Geographic magazine and National Geo-

*graphic's January/February 1996 Traveler magazine have high-
lighted the canyon, the Wellsboro Diner, and Route 6, as it wends
its way across the state.*

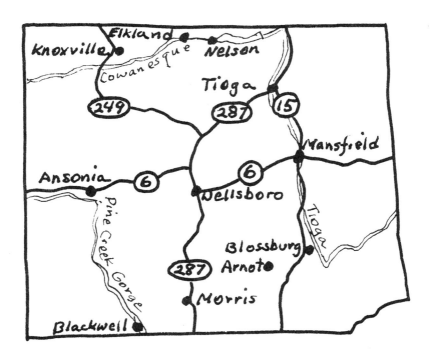

Tioga County

Clear the Other Side of Everywhere Aint So Far from Here

by Bonelyn L. Kyofski

When I was a child, my grandma was too busy to tell her family stories often; so my favorite became one that went ninety miles an hour by horseback and could be finished in 45 seconds. It was about Jack, going to find Mother Clinton's house, which "blowed clear away in a gust of wind." Full of built-in contradictions and unlikely characters, it had a marvelous finish. John Ironsides knew where the house was: "Blowed clear the other side of everywhere, where the mad dog bit a hatchet, and pigs run round with knives and forks stuck in their back, squealing, 'Hold the Pork!'"

One of dozens of stories featuring the Giant Killer, this story is one Grandma learned from a logger who worked for her father in the 1880's. It has been documented as a "Jack story" unique to northern Pennsylvania

Bonelyn L. Kyofski

"Grandma" Pearl Short Hess, schoolmarm in Tioga County, 1902, passed along stories to her students and grandchildren.

and to Grandma's telling of it. I've always surmised that the other side of everywhere was right here—our own equivalent of "East of the Sun and West of the Moon." So of course Jack would have no trouble finding his mother's house. To my ears, Pennsylvania North Country is the perfect site for folklore. We have a lot of it, and we have a lot of appreciation for the word well-said.

However, a few years ago, when I was asked to be involved in identifying some of the cultural treasures that might be unique to the Northern Tier in the interests of recognizing, saving, documenting—and ultimately outlining the cultural and physical qualities that may make Headwaters Country an identifiable entity—I began to get more of a sense of just how much of an odyssey Jack found himself on, following that vagrant wind.

The task was, based on my love for stories and my general familiarity with the northern counties of Mr. Penn's woods, to try to discern a specific area for our folklore and indeed define what our peculiar appreciation of the spoken word is in the North Country. My brother, Tony Lugg, backed me up in this picaresque adventure, which opened up some possibilities that we will no doubt be following by bits and pieces for the rest of our lives. We learned that many of our childhood experiences were, beyond our extended family's ongoing practice of them, valuable folkways — part of the fabric of folklore.

For the most part, we know our native Tioga County well. For my first twenty-four years, Tony's first twenty-three, our parents — first Dad then Mom — were county commissioners, a position where, in the 1940s, 50s, and 60s, family visibility was a requirement. So, from community picnics, parades, snake-hunts, centennials, radio station openings, ribbon-cutting ceremonies at new bridges, dam dedi-

cations, receptions for the governor or senators, election nights at the Court House, county and town fairs, fish stocking adventures — and — most of all, lots of family and friends get-togethers — we, along with our older brother, John, learned the important stuff.

We knew where the coal mines were, the company towns, the place of the first labor riot in the United States, the spot high over the valley where that last miner in the last cable car froze because they didn't know everyone hadn't got home that night. We knew the hollow where they found that golden rattler and the trout streams where there were native rainbows. We heard stories from people who had begun working in the mines at 10 and 12 — younger than we at the telling — and I had sat at the feet of old ladies crocheting and making rag rugs and talking about how they would have loved to go to "the academy."

Our own family had been farmers and loggers and schoolteachers here since the early 1800s; so we felt also that we knew the rural identity fairly well. We still live in a culture where family animals–and farm machines, like "Old Mike, the steam engine" — are legendary over generations for their speed, strength, loyalty, amiability, or simply being "smarter'n some whole families"; where folks make maple syrup, raise chickens, butcher pigs, "cultivate" wild ginseng, hunt and fish–all for more fun and tradition than profit; where people don't talk much about it but are truly married to the land in either a love-match or a union where slavish dedication is justified by living with breathtaking beauty. All this, and we have some towns, too. (Several have over a thousand people!)

For 20 of the first 30 years of our lives, the Army Corps of Engineers was in the process of planning to displace our family from our 170 year old homestead, together with dozens of other families in similar circumstances, for three dams to be built in the county.

We fought first not to have to move; then to accommodate in the best interests discernable for the next generations; and in the last twenty years to adjust to and shape a new regional and personal view. Throughout, in the threat of oblivion for our old places and manners, our regard for our world has been questioned and tested and challenged and looked at from faraway places. In short, we have for this land an intense sense of ownership that we share with hundreds of natives and adopted kindred and which we expect to last as long as we do.

In our new intensive search for "folklore" of the area, I simplistically thought that Tony would be the expert on the "stuff" and I would do the stories. Tony, like several of our Hess cousins and many friends, typifies one special kind of northcountryman. He is one of the "Foxfire" children — builds, rigs, butchers, cooks, pickles, designs, digs, grows, gathers, collects, regales, researches, charms. He has contributed much of the credibility that one needs in seeking out certain folkways; he has been doing it all his life. As children, when I was asking "what?" of the old folks, he was asking "how?" He's the one who got Gramma to experiment with him with Grandpa's recipe for grafting wax and watched them shoe the horses. But my view that our arenas were separate didn't work; our working lore is the detail of the stories–just as it's the proof of identification that allows me access to other people's stories. And Tony has better story sense than I do.

So what makes the stories? Today, the carrying on of the old skills accommodating to modern constraints is one delightful source of the stuff of contemporary folktale. One of my non-traditional students, Al Horning, a maple syrup revivalist, told me the other day that he built a special shed for "boiling off" after his first season when he had steamed all the wallpa-

per off his house. (That's a gross but uproarious image to anyone who has stood near that boiling sap; the wet air is redolent with sticky sweetness. And all of us country folk do our own wallpapering, but only when it needs it — preferably once every twenty years. And all revivalists know the feeling of "Oh, I didn't realize *that!*" in trying a simple-sounding process. It's the shared pain–the understatement on one hand and a little exaggeration on the other–that make the humor.) And that he said it all in one dependent clause is art.

Maple syrup culture obviously is a rich source for folklore. The Kinnan/Deats/Brown clan use their beautiful Century Farm and maple syrup tradition in the interests of public schools, tourism, and progressive education. As part of their outdoor maple museum, the current Maple Queen performs a living history representation in their woods of an Indian maiden's discovery of the sweet stuff. Other Century farmers with their one hundred year husbandry on a cherished piece of earth are great sources for customs, tool and implement use, techniques, recipes, hog-butchering, quilting, trapping, surviving traditions, local and professional knowledge of our cultural and physical geography–as well as the stories that go with it all. The Pino family in Cherry Flats annually hosts a very popular antique farm implement day with involvement and demonstration. "Farm City Day" is annually sponsored in the various counties by the Farm Service Agency and Soil Conservation District as a tribute to the local farm industry.

The county fairs have offered over a century of economic and social celebration of the work of our region. We see a modern appreciation and application of the old arts as a community venture. Twenty years ago at the fairs we would have found only a small cadre of sheep farmers in this more predomi-

nantly cattle country. Today, however, we find the sheep farmers working with revival artists who are also raising the occasional sheep and trying the more unusual breeds for variety in wools for their home-spun arts, both knitting and weaving.

The work of other industries of our area — lumbering, mining, tanning, glass, railroading—all are equal in folklore elements. Though the farm culture has the largest population to engender the stories, logging and railroading, in particular, have found historians to document much of their heritage. The histories of tanning and glass in our area deserve some heavy attention. We have much to conserve.

A treasure trove unique to our area which merits lots of acknowledgment and serious work is Joe Surina's film collection. Joe Surina (1894–1958) was a beaming giant who had come to the United States from western Yugoslavia in his — and the century's — early years. As a "type", Joe was distinctly Mediterranean, with a charming accent and an ebullient manner. He loved to dance and sweep people off their feet, always had children surrounding him. Joe was in love with cameras, boats, planes and parades; with his 16 mm. movie camera he "shot" all the significant public activities in Elkland, as well as some in Galeton, Corning, Big Flats, and New York City from 1936 to the mid-fifties. In Joe's films are not only documentation of local daily folklife, but also significant historical details, such as footage of the 1936 leatherworkers' strike taken near the Elkland Leather Company and the Tioga County Court House, a spectacular pre-World War Two international glider meet at Harris Hill, Elkland's 1945 Victory Parade, and scores of floods, snowfalls, and parades. As a photographer, he knew a story when he saw one.

In remote areas, it is difficult to maintain the arts; often the fine arts, including literature, of course, are

easily lost. Some people, though, who had not the leisure to tend votive fires, still often kept sparks alight in their environment in hopes of saving the flame for more auspicious times. In our kind of area, where one can hear uproarious local color stories on a street corner at any given time, a person whose ear is tuned can appreciate that a love for colorful language and *le mot juste* has been carefully nurtured, despite a perception of no regard at all for standard usage.

I've always loved Mark Twain's line to Livy, when in an effort to improve him she echoed one of his profane and eloquent outbursts: "Livy, Livy. You've got the words but you don't have the tune." Livy grew up only a dozen miles from us, and contrary to what the New England critics thought about that lovely, cultured lady, we country neighbors know that Livy had experienced frontier earthiness before Sam Clemens came to Elmira. Nonetheless, a person listening to a story in the North Country today will sympathize with poor Olivia and her inability to "sing" the vernacular. Someone will use an ain't with two more negatives, a slight vulgarism, in a blazingly perceptive remark about human nature; I will be convulsed in laughter, but despite my appreciation, there ain't no way'n hell that I can reproduce it. There are cadences and inflections, elisions and omissions — to wonderful effect — and some people can verbally bestride the styles. Some of our North Country elders are remarkable in capitalizing on our gorgeous literary heritage and also the common tongue. Grandma, a schoolteacher, was one of them; like Livy, she fought to erase the "incorrect" from her family's diction. (With some it worked, with some it didn't.) Nonetheless, she knew the power of the vernacular and its wonderful ability to bridge the difficult with humor or salt, and she must have sent mixed signals to my mother's generation as well as enchantment to mine.

My grandmother's stories are examples of maintaining the heritage and saving the charm—and the warnings — of the past; however, Grandma knew you could uphold the classics, while still belting out some colorful idiom. When she was ninety and I was a thirty year old Ph.D. candidate in English, she could pace me chapter by chapter in any of Dickens' novels — without book in hand. She attributed all social progress in England and in the United States to Charles D. Himself and inhaled modern novels — all except Steinbeck's. She said she never picked up a book of his that did not have the word "whore" on the first page. She didn't mind the word particularly, but used so gratuitously, she thought it was a bad habit. Her folktales and histories that we regale the school children with today are true stories of her pioneer ancestors; tales that she heard from the loggers who worked for her father and from her students and families in their one-room schools; stories that her mother, another schoolmarm, passed down from her family and experiences in pioneer country. That grandma, Gramma Short, hurried home from school in winter twilights not only because not freezing demanded it, but also the wolves' howling came too close.

In my searching out stories and the trails of local lore, I talked with "Sherd" (Sheridan) Husted a couple of years ago. Not in a remote spot with microphone in hand, it was in a local restaurant with coffee where we happened on each other, a remarkably common locale for folklore today. Sherd's grandmother told him about the wolves also. She said that one night the wolves' howling came from all directions and went on for a long time. Never again did they hear them. The old folks believed that that was a council that night, the wolves had decided the land was becoming too populated, and they had moved on. No one at the table with Sherd and me disputed it.

Sherd tells another of his grandmother's stories as well. There was an Indian woman who on occasion would stop in at one of the Cowanesque Valley cabins; one visit she hung her baby in its carrier from a tree limb outside and went into the cabin. Some of the older children decided to play an old frontier trick and borrowed a family baby and effected a switch. The woman left the cabin, slung the baby over her shoulders, and left posthaste. No one ever had a further explanation except that the people following her with her own baby had a terrible time overtaking her and straightening the babies out.

Storytelling–like folk music into operas and symphonies–translates into "literature" when need and effort arise; there is no conflict (outside of grammar) at their existing side-by-side. Our "flame keepers" seemed to have been successful in engendering love for the word in some who later became "serious writers."

Grandpa Lugg, the other side of the family from Grandma Hess, was given the traditional family name for his two grandfathers, Charles, and Byron–for guess which Lord. Not at all a Romantic hero otherwise by the accounts I hear, Grandpa Lugg was a tobacco farmer with twinkling brown eyes, who would regale the family by striding up and down declaiming lines from Sir Walter Scott's poetry. Not remarkable particularly, except that liberal association with *two* Romantic poets is not usual in the North Country.

Folk tales often cluster around larger-than-life people. One was Ole Bull, in whom Coudersport and Galeton share "ownership." Ole was the Norwegian violinist who planned the utopian settlement that became Oleona. Ole's larger than life *persona,* a good fit with the roistering North Country lumbermen, is a wonderful folklore source. His legendary poetic styling of Norwegian folk melodies, his love for "liberty,"

the local belief that on certain nights when the atmos-
phere is right we can hear Ole's final lament on the
hilltop before smashing and burying his violin, the
"castle" ruins themselves, and of course Ibsen's ac-
knowledgment of Ole as the model for "Peer Gynt," all
have mythic proportions.

Another such story-attracting person is Mary Jemi-
son, the White Woman of the Genesee, who lived
much of her life forty or so miles northwest of this
headwaters area. As a young frontiersperson she was
captured by the Indians near Pittsburgh, and eventu-
ally lived out her life near the Genesee Gorge in New
York State, now Letchworth Park. Though the trail
covered by Jemison and her then Indian family from
southern Ohio to New York State several years after
her initial capture is documented as being far west of
our area, our legend still claims her. "The Jimison," a
north-south flowing creek in the western half of Tioga
County, is reputedly named for her, still claimed to be
the path her captors brought her fleeing north after
her capture. The story apparently has no basis in fact,
though there definitely were Iroquois paths through-
out the county, and artifacts exist that prove hunt-
ing/camping sorties into this area at the time she lived
in a Seneca community just to the north. In any event,
she is a favorite heroine here.

The position of this area in Native American history
certainly has not been developed. Indian trails of
which there are still physical traces are not acknow-
ledged on many Commonwealth maps that claim to
document Indian paths. Perhaps because this was
Iroquois territory, site of the "Forbidden Path," Dela-
ware/Susquehannock lore might not have compre-
hended it; however, many old settler tales survive of
experiences with the Indians. And the names of some
Indian characters remain current.

There's an old story among English teachers that

the perfect story includes religion, royalty, sex, repetition and suspense. Of course, the star student blurts out: "'Oh, God,' yelled the Queen. 'Pregnant again!' I wonder whodunnit.'"

If those criteria are at all valid, the North Country had ideal material for perfect stories in the last years of the 18th century. There were three queens strongly influencing the region. The first two were sisters — Queen Catharine de Montour and Queen Esther. Their grandfather was French, and their grandmother was a famous Seneca linguist and translator for the English and French prior to the French and Indian War. The sisters were part Mohawk and part Seneca, and Catharine, in particular, inherited her grandmother's facility with language. Both married chiefs and both were subsequently elected chiefs themselves. (Women chiefs were not unusual among the Iroquois; some consider the Six Nations a complete matriarchy.)

I often use the story of the sisters to illustrate for students that the winners write the history books. In the native American heritage, Catharine and Esther are impressive and effective war chiefs. In one turn of the century historical novel,[1] Catharine is referred to as "The Toad Woman," or "The Huron Witch," an ugly hysteric who "scurried" like an animal through the forest to whip the tribes into a killing frenzy to fight the white man.

Esther is quite simply known as the "Fiend of the Wyoming." After her teenge son was killed on a hunting sortie by white soldiers, she went on the warpath–her band took fifteen prisoners. There are two escapees, one of whom lived to tell the tale. Queen Esther personally tomahawked the thirteen captives. Her tribe then attacked the Wyoming Valley settlements–the "Wyoming Massacre."

Pennsylvania's Montour County is named for the

*Farmington Hill Cub Scout den with Bonnie Kyofski celebrating
Halloween with stories in 1995.*

queen's trader/linquist grandmother Mme. de Mon-
tour, according to the *Pennsylvania Manual,* and Mon-
toursville in Lycoming County for Andrew,
grandmother Mme. Montour's son. The Iroquois were
famous for keeping their enemies at a distance. Be-
sides keeping the Northern Tier as an off-limits buffer
zone, they often established villages of conquered
enemies–or non-threatening allies — as occupied ter-
ritory between them and Philadelphia. Mme. and An-
drew evidently were delegated to lead such
settlements for a time. Their names did not hold the
infamy of the Northern Queens, perhaps because

they antedated the Revolutionary War. (Montour is one of only two counties named for women among Pennsylvan's 67. The other is Huntingdon, named for Lady Huntingdon, Duchess of Bath, the daughter of the sponsor of the Williamson Road–now Route 15–our first road north through the wilderness.)

And the third Queen? She is Marie Antoinette, the best-known subject of folklore in the Northern Tier.

The story of Marie Antoinette's colony at Azilum could hardly be more dramatic: a little group of French aristrocrats having themselves barely escaped death in the French Revolution, preparing a home in the wilderness for their Queen. So many elements of the story are enormously appealing–the devoted hope of the emigres, their totally unaccustomed physical work in encountering the wilderness and the bitter weather, the sheer beauty of their environment on that curve of the North Branch of the Susquehanna in contrast with the horror of the Queen's destiny, the questioned fate of the Dauphin.

The subsequent lives of the colonists are stories of human courage, accommodation, and adaptability. In some cases, their nobility was probably more challenged at the "Grande Maison" than at Versailles. Wonderful history and wonderful stories.

Years ago in a folk music course in Kentucky I heard Pete Seeger's arrangement of "Oleanna," which the professor said was related to a proposed utopian settlement "somewhere." In looking up the complete lyrics then and finding an earlier version again later in an Ole Bull biography, I discovered that a contemporary (1850s) verse went: "Little roasted piggies/ Rush about the city streets,/ Inquiring so politely/ If a slice of ham you'd like to eat." Mad dogs and hatchets weren't mentioned.

Somewhere?

Our folklife project has included oral history inter-

views, filming, and much wonderful reflection with delightful people, as well as the writing of this book. The dearest part of the project for me, naturally enough, was the video documentation of some of my Grandmother's stories. Though I've come to appreciate that "folklife" and "folk arts" are defined as how people live and express themselves in consonance with their traditions—in other words, virtually everything we do in the North Country — still from my early bias, from my heart, folklore begins and ends with Gramma's stories. In the filming, my college students and local elementary children are involved with the stories, and Tony's daughter Anne, my ten-year-old niece, blithely tells her family a Jack tale her great-grandmother heard from a woodsman one hundred year ago.

Clear the other side of everywhere?

Not so far from here; not so far from here.

Chapter 10

Potter County Overview

The land included in Potter County was part of the purchase from the Indians at Fort Stanwix in 1784. When the county was created out of Lycoming in 1804, it was named for General James Potter, one of Washington's subordinates.

Settlement began in 1808 when William Ayers moved in. The next year Major Isaac Lyman settled at Lymansville where he built the first grist and sawmill, opened the first tavern, held the first court and served as the first postmaster. Until 1815 the county was attached to Lycoming, and then Potter and McKean maintained a joint government. In 1824 Potter elected its own commissioners and finally in 1835 a courthouse was built and the first court was held. It was now an independent county.

For the first one hundred years, settlers lumbered the dense forest and cleared ground for small farms. Then the white pine was in demand, so it was cut first. By 1850 there were eighty-three sawmills in Potter.

After the white pine was harvested the loggers turned to the hemlock and hardwoods and it was during this time that the county reached its peak of prosperity. In the mid 1880's railroads were built to aid in the timber harvest and marketing, which helped other small industries as well.

The population reached 30,620 in 1900, but within a few years the timber was gone and the workers began to move away. The discovery and the drilling of deep natural gas wells during the 1930's revived some activity, and more recently small industries have sprung up.

Today the many state parks, the Pennsylvania Lumber Museum and nearby Denton Hill Ski resort attract tourists. Access is afforded by Route 6, the "GAR Highway," a part of the highway system that preceded today's Interstates. Cutting across the Northern Tier, it was a tourist route par excellence during the 1950's and is still lined with charming motels, cabins and restaurants.

Potter County

A Forest Heritage

by Robert Currin

The forested hills of Northcentral Pennsylvania have a great influence upon the lives of the people who live among them. From the time of settlement until the present, the forested slopes have never surrendered their hold. The thin, rocky soils on the sides of the hills make farming almost impossible, while on the tops of the plateau, the soils provide more abundant crops. Since the prevailing topography is hillside, much of Potter and its neighboring counties are covered with a vast forest canopy that has not been disturbed except by the logger.

Working in the forest or with the products gained from it has been the destiny of the people of Potter County. Generation after generation have used the timberland for livelihood and recreation.

Woodcarving

The art of carving, as practiced by John Scholl, the wood-carver of Germania, Wayne Burrous, who worked and carved while living along the West Branch of Pine Creek, and Anton Jeleznik, an Austrian immigrant, left a great legacy of folk art. At present, Nancy Jones, noted as a creator of carousel horses, produces hundreds of beautiful artistic carvings. Her home and workshop near the headwaters of the Allegheny River are a showplace of her work. Nancy started carving after taking a one week course at the Pennsylvania Lumber Museum. Since then Nancy has become one of the better known carvers in the northeast, and her work has found its way into many parts of the country.

"Because it is fun," is the reason that Leonard F.

Treat of Roulette gives for his interest in carving. "It is so relaxing that you can lose yourself in time, while the cares of the world seem to vanish." Leonard, who served in the United States Navy during World War II and was later employed for many years by the North Penn Gas Company, can trace an interest in the hills and forests back for several generations into the late 19th century.

His grandfather Isaac worked a farm and also as a timber jobber. The jobbers were in charge of the crews of men who harvested the timber. As a skilled craftsman who made fishing rods from the wood of the Juneberry tree, Isaac Treat influenced his grandson's lifetime interest in wood. Grandfather always had a jackknife, so Leonard always carried a knife, which the elder gentleman taught him to use. Learning to make a whistle from the striped maple was one of his earliest assignments. Together they made a lot of shavings and created many small whimsical items. Leonard's great respect for his grandfather and an appreciation for the skill which he was taught has led to a lifetime of enjoyment.

Leonard's father, Fordyce Treat, worked with wood as a carpenter. He was a builder, not a carver. The years of the Great Depression really didn't offer much opportunity for a hobby, as it was a full time job providing enough to raise a family.

Leonard Treat is a patient, soft-spoken, diplomatic individual; his whole demeanor demands respect. He claims that all it takes to be a carver is a sharp knife. A band saw to cut out the rough patterns also helps. He makes it sound as though anyone with a knife could do what he has done. It just doesn't happen that way. I have tried it.

He does most of his whittling or carving in a garage workshop where he keeps a stove for heat during the winter and as a place for his mistakes. His favorite

wood is basswood, which he finds the easiest to work, but he also uses cherry, walnut and maple. Most of his wood is obtained by his son, who gets the short pieces that are often cut from logs at the mill before they are sawed. These pieces are sawed into blocks at a band sawmill and kiln dried before they are ready for use.

His subjects include dogs, birds, cowboys, and Indians. His characterizations give special pleasure to the creator and to those who observe them. Not everyone can serve as a model for one of these whimsical characters, but often Leonard will see a person who would make a good subject and then observe him for a long time before going to work. His skill with the knife is similar to the artist's skill with a pencil or brush. It is an honor to become the subject of one of these pieces, although I am sure that not all of the subjects have been told that they were models. All of these creations are worth scrutiny and some chuckles, but his A Shotgun Wedding is a masterpiece, complete

Potter County Historical Society

A Shotgun Wedding by Leonard Treat

with the presiding magistrate, the grieving mother of the bride, the father with gun in hand, a very subdued groom and, of course, the bride whose condition shows that she is in need of a husband.

Not all of the work is whimsical. The many birds, dogs and other animals, and even some of the people are of a more serious nature.

Leonard is always willing to share his knowledge and skill with anyone, but he does not sell his work. To him this would take the fun out of it. The hobby is only relaxing without a deadline; there is no pressure if you can carve for several hours and then go fishing. This is a hobby, not a profession.

The members of the Treat family all take an interest in the work, and another generation is gaining an appreciation for the forests and their products. Leonard Jr., with an associate degree in Forestry, works as a timber buyer and a lumber scaler. A daughter, Rhoda, does some carving and paints scenes on circular and crosscut saws, important tools used in the forests' harvest.

Pine Tree History

Long before Leonard's grandfather's time, when our first New England forebears reached here in the early 19th century, they found vast white pine, hemlock and mixed hardwood forests that to the farmers were not friendly. Before anything else, the trees had to be cut. No markets were available and transportation was over a few mud covered trails; so "What do we do with the logs?" was a general puzzle. A few sawmills were built to provide lumber for local use, but most of the trees were piled and burned or left to rot.

Soon logs and lumber were transported to market by rafts or as loose logs on the streams. Even the finished lumber and shingles were sent downstream on rafts or arks. Because of our location on the head-

water streams of three rivers, the Genesee, the Allegheny, and the Susquehanna, products could be sent in any direction of the compass.

The commercial lumber business began in Potter County in 1837, when the Oswayo Lumber Company was organized at Millport to market the white pine timber in the Oswayo Valley. Mills in Hebron also sawed mostly white pine.

By 1850, when the county population was 6,048, there were 83 sawmills producing over twenty million board feet of lumber. Only two of the mills were operated by steam. All of the others were the old up-down type that depended upon water for power and had a daily cutting capacity of only 1,000 feet. A typical mill was operated on the family farm during the off season for agriculture. Well over 90% of Potter County people enumerated in the census gave their occupation as farmer.

The era preceding the Civil War saw the development of the log boom at Williamsport. The boom, a containment structure used for sorting logs built in the

Lycoming County Historical Society
The Duboistown boom at Williamsport, on the south side of the river.

Susquehanna, was completed about 1850, and Williamsport grew to be a lumber center over the next 20 years, having a good deal of production during the Civil War because of the need for lumber for war materials, such as ships.

By the 1860s Williamsport had the largest sawmilling industry in the world, using logs from the headwaters of the Susquehanna River. Southern and eastern Potter County were in that watershed, so rafting and log driving became important activities and many young farmers would seek employment on the streams during the spring run off. Planting might have to be done without them, but most were home for fall harvest.

Logs were also transported on the Allegheny. It was a thrilling journey for a young backwoodsman to go downstream as far as New Orleans, although the destination for most was Pittsburgh or closer.

About three out of four residents in 1850 were Anglos of New York or New England descent, but by 1860 other ethnic groups had found their way into Potter County. Norwegians, Irish and Germans had established settlements and their influence was becoming felt, but the staid, conservative Yankee still prevailed.

Second and third generation New Englanders continued their westward movement with some staying here for only a few years. Kansas, Nebraska, Michigan and Wisconsin were favored destinations, the former two creating a large following for the Free Soil Movement. Letters from Kansas appeared almost weekly in the newspapers and donations were sent to aid the movement there. When the Republican campaign began in 1856, Potter County supported several Fremont Clubs. James Buchanan, a favorite son from southern Pennsylvania, didn't mean much to the Yankees and the county went to Fremont. The next

Presidential election was a definite victory for Lincoln and the Republican Party.

The 1860–70 decade saw a decrease in population as the westward out-migration continued more rapidly than the in-migration, which was still from New York State. The southwestern corner of the county was lost to the newly formed Cameron County in 1860. The village of Lewisville (Ulysses) was incorporated as a borough in 1869. Farming was still the primary occupation, but larger sawmills began to appear and the forests in the northern part of the county began to disappear.

The harvest of the stately pine forests continued at a brisk pace. The mill of Norman Dwight in Hebron was cutting 18,000 to 24,000 feet daily, and by 1879 only 1,000 acres of pine remained in the Oswayo Valley. Larger plots remained in southern Potter, but since harvest had begun there soon after the Civil War, the days of the pine tree were limited. Many pine logs were splashed to the log boom at Williamsport, and by 1880 the pine was losing its importance. The *Potter Journal* for December 3, 1883, reported the cutting of one of the few remaining large trees while lamenting the passage of the white pine. This tree measured 54 inches across the stump and from it were cut ten 16-foot logs and seven 12-foot logs for a total of 244 linear feet.

The Hemlock and Mr. Goodyear

Many thousand acres of hemlock and hardwoods remained. The harvesting of these revolutionized the lumber industry. Hemlock was the predominant tree in southern Potter County but until the 1870's was considered worthless except for its bark.

. Mr. Frank H. Goodyear was engaged in lumbering on a small scale in McKean County when he began to plan for lumbering the hemlock forests along Free-

John Fidelinger

White Pine and Hemlock

man Run Valley in Potter County, where he purchased large tracts of timber. He had an idea that faster transportation would enhance the harvesting and marketing of the forest products, so he introduced the railroad into the industry. In 1885 he built a railroad from Keating Summit to Freeman Run. The village there would be renamed Austin and become one of the busiest, fastest growing towns in the Common-wealth. By 1890 the newly incorporated borough con-tained 1,670 people, and the surrounding townships were also prospering. Villages and logging camps sprang up in each area as the timber was harvested.

The Austin hemlock mill had the largest capacity of any in Pennsylvania at the time and quickly cut the timber from along Freeman Run. Then other timber-lands were purchased and the railroads were ex-panded into new areas, continuing to carry logs to the Austin mill.

Hemlock bark provided tannic acid, which pro-duced a second industry. The bark was peeled from the logs and sold to the tannery at Oswayo, or to the new tannery at Costello, which benefited from the

railroad and expanded to become by 1895 one of the largest of its kind in the world. The abundance of the tannin laden bark also brought tanneries to Galeton, Roulette, Coudersport and Harrison Valley.

Thousands of people came to share the newly found prosperity. In 1890 A. G. Lyman had built a hardwood mill just south of the Goodyear mill and took advantage of the railroad to transport the logs to his mill. The sawmills at Keating Summit, Pike Mills, Mina and Mills flourished. Once worthless hemlock was now held in high esteem. This was the Potter County that Leonard Treat's grandfather Isaac remembered.

Now immigrants from southern and eastern Europe began to arrive. The Italians came to work on the railroads, while the Swiss, Polish, Austrians and others moved into the tannery towns.

The lumbermen who moved camp to keep up with the cutting were from Canada, Sweden and many northern and eastern states. Another group of mostly

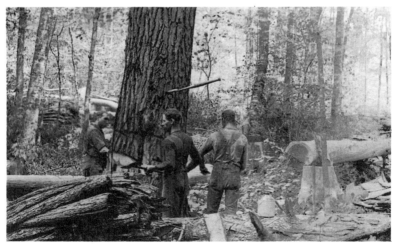

Potter County Historical Society

Preparing to fell a large hemlock. Note the peeled logs, the bark and the bark spud stuck in the tree. Stoneware jugs for water or refreshment appear in many photographs of the period.

single men worked as bark peelers during the spring peeling season. Others came to work in the stave and heading mills, the kindling wood factories and other allied industries. It was primarily a man's world. The kindling wood factories were the first local industries to hire women. Later the clothespin factory and the glass plants would follow suit.

The Goodyears did not have a monopoly in the local lumber trade. A. G. Lyman specialized in cherry. Then there were R. W. Clinton and Sons at Galeton, Emporium Lumber Company at Galeton and Austin, Central Pennsylvania Lumber Company at Mina, Horace A. Avery at Keating Summit, J. J. Newman at Sweden Valley, and the Lackawanna Lumber Company. Most depended upon the Goodyear Brothers Railroad for transportation.

The Scranton based Lackawanna Lumber Company constructed their first mill on Lyman Nelson Run near Coudersport. The new village nearby was named Mina in honor of the superintendent's wife, and soon grew to several hundred residents, with a railroad station, a post office and a store. After a few years the company moved their headquarters to the Kettle Creek Valley and built a large mill there. This new village was named Cross Fork and grew to over fifteen hundred residents.

In 1893 the Goodyears renamed their railroad the "Buffalo and Susquehanna" and extended it to Galeton, where they established railroad yards and shops. They purchased the Clinton Mill and increased its capacity. Three of the largest sawmills in the state were rapidly consuming the once vast county forests.

It was the boom period for Potter County. In 1897 Austin was second and Cross Fork was third in state lumber production. Only the Williamsport mills, that were cutting the logs sent down the West Branch of the Susquehanna, were cutting more. When the Gale-

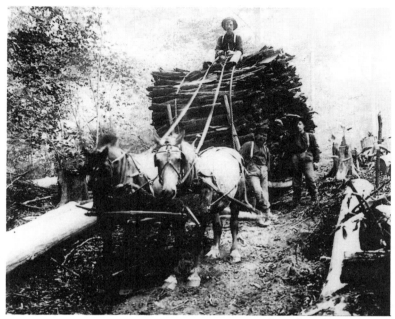

Potter County Historical Society.

Sledding bark from the forest to a landing, where it will probably be flumed to a railroad car.

ton, Austin and Cross Fork mills were all operating, no Pennsylvania county was cutting more lumber than Potter.

Transition

Soon after the beginning of the 20th century, the population of Potter County was at its peak. The 1900 Census listed 30,620 people and ten years later the county still had 29,729 residents. But in about 20 years the timber was harvested. People moved away. As World War I approached, the mills closed and the cut-over timberland was sold. In several areas chemical companies acquired thousands of acres and constructed facilities for producing wood alcohol, charcoal and other chemicals. Galeton, a busy community of 4,027 in 1910, counted less than 3,000 in

1920 and for the next fifty years it continued to decrease. Villages like Hull, Nelson Run and Corbett in southern Potter disappeared. Both Mina and Cross Fork are ghost towns now, and Austin is known best for the ruins of the dam that collapsed, washing most of the town away.

Population in the north also decreased, although not to the same extent. In 1970 the county population stood at 16,395. And as the number of residents declined, the number of game animals was on the rise.

The vast forestlands began to play a new role in our economy. The thousands of acres of cut-over land, owned by the lumber companies and no longer of any value to them, were sold for an average of less than three dollars per acre. A few small tracts were purchased by individuals but thousands of acres were sold to the Commonwealth of Pennsylvania to become State Forest Lands. Potter County, with 265,854 acres of these lands, has more state forests than any other county.

These state forests are now managed by the Department of Conservation and Natural Resources and are being harvested once more. This time around, the value is not in pine or hemlock, but in cherry, maple, oak and other hardwoods. Pulpwood for the manufacture of paper takes thousands of feet of pole timber from our hills. The railroads which crossed the county are gone except for a few miles at Keating Summit. Today trucks travel to the timber source, making a more convenient method of transportation.

Hunting and Recreation

The forests had been used to aid the great westward movement; now a new era began. Hunting and fishing had been important for the first settlers at certain times of the year, but trying to make a living from the soil left little time for recreation. Most people

turned to the forests only when the need for food was greatest, during the winter. Hunting and fishing were part of the struggle to exist in a new land.

A few pioneers were commercial hunters and became well known for their skill with the rifle. Among these was Clark Crum, who moved from Tioga County, New York, into Ulysses Township in February 1831. With money earned through the sale of game, he purchased his land and had it cleared. Mr. Crum is credited with killing a total of more than 1,500 deer, 31 black bear, five large gray wolves and numberless wildcats, foxes and panthers. He captured panthers and wolves to sell to zoos and made numerous trips to Jersey Shore, Pennsylvania, to sell meat.

Little is known about most of the early Potter County hunters since they left nothing in the way of written records, but two in particular left extensive notes and diaries. Laroy Lyman, born in Roulette in 1821, was the son of Burrell Lyman, and the grandson of Isaac Lyman, the second permanent settler in the county.

At an early age Laroy became an expert on the habits of many game animals. Later he exhibited captured animals and lectured about hunting excursions and the animals he sought. In his own record he stated:

> I have killed about 3,000 deer, over 400 bear, more than 300 wolves and hundreds of wild cats, otter, martin, mink, coon, lynx, foxes, fishers, hawks, owls, eagles, geese, pigeons and others.
> I have shot seven deer in one day, six in half a day, and a good many times five in one hour, four in one minute, two at one shot.
> I have killed seven wolves in one day, and four bears out of one tree. I have captured four bears alive in one tree. Also caught, raised and tamed deer, wolves and bears.[1]

He not only hunted. He was a farmer who prospected for gold, speculated in the new oil industry, and traveled and hunted in the west and in New England. Once while visiting in Indiana he wrote home that, "It is a good thing for the Potter people to stay at home for if they did once come out west, they

would be discontented and never be as good to work again on the rough, rooty, stony, uneven, hard, yellow soil, that never pays them for their work."[2]

Laroy came home and worked his farm and roamed the hills. His influence is still seen on today's map. Several Lyman Runs are named for him, and Bark Shanty Run was named for a bark covered hunting cabin that he had built along the stream.

Probably the most famous Potter County hunter was E.N. Woodcock who had his hunting experiences published in the *Hunter-Trader-Trapper* magazine from 1903 to 1913, and issued in book form in 1941, titled Fifty *Years a Hunter and Trapper.*

Born at Lymansville in 1844, Mr. Woodcock was 23 years younger than Laroy Lyman, but was his cousin. Like Lyman, Woodcock gained his early experiences near home and later traveled to hunt in other areas. His toured the west coast and the south, but most of his hunting and trapping was done nearer home. He came too late to hunt the elk, wolf or panther here, but hunted them out west. He was particularly noted as a trapper of the black bear.

Around the turn of the century the number of deer in Potter County decreased to the point that the sighting of one made the local news. Those who were inclined to hunt would go into the cut-over area to build a temporary camp. They would spend the next week or so scouring the area. Small game was plentiful, but bagging a deer was luck indeed.

About 20 years after the Pennsylvania Game Commission began operating, it decided to stock Michigan whitetail deer in Potter and the surrounding counties. After a slow start, the whitetails began to increase rapidly. With automobiles now providing speedy, cheap transportation into the area, Potter County became a hunter's paradise. Hunting camps were built and local residents opened their homes to

Potter County Historical Society

Laroy Lyman's home, built in 1848, Roulette, Potter County
Pennsylvania.

the downstate and out-of-state nimrods. Income from
hunters became an important addition to the faltering
economy.

Not everyone was happy. The deer herd increased
to the point that a search was begun for ways to
control damage caused by too many hungry animals.
As the forests matured, deer browse was choked out,
and the whitetails migrated closer to farms, causing
even more cropland damage.

Potter County gained bragging rights, since for
over 40 years it led the state in the number of deer
harvested. It was the premier hunting county. The
success of a hunter one year would bring more in the
following year. The number of Christmas presents
often depended on the cash spent by out-of-area
visitors, and businessmen relied as much on the hunt-
ing season as on the Christmas rush.

The deer herd has now spread into more suburban
areas of the Commonwealth, taking the game closer
to the hunter. It is no longer necessary to travel several

hundred miles to get a deer, so the number of hunters in the traditional deer counties has decreased. Potter no longer leads the harvest but remains high on the list.

This change can be seen in the towns on the Monday after Thanksgiving, the start of buck season. During the late 1940s and 50s this was the busiest day of the year. Streets were swarming with red coated hunters, stores doing a bustling business. Today there are still hunters in town, but you would hardly know buck season was starting. Hundreds of hunters still scour the forests, and the camps are usually full, but the vast crowds have diminished to a more manageable number. Now the year around tourist trade has become increasingly important, while the business created by visitors remains an important source of income throughout Potter County.

Two Words to the Wise

We wish to share the beauty of the countryside, but please leave a few dollars behind. And if you notice a dignified man with a knife, whittling and looking your way from time to time, you might stroll over to see what he's carving. Your "characterization," and your heart may be here to stay.

Chapter 11

Cameron County Overview

Created March 20, 1860, by the State Legislature, Cameron County was the next to last county formed in Pennsylvania. It was made from parts of McKean, Potter, Clinton and Elk Counties, all formerly parts of Northumberland County, together with land purchased from the Indians in 1784. It was named for U.S. Senator Simon Cameron, a Pennsylvania newspaper man and a member of President Lincoln's cabinet.

Cameron County, one of the smallest counties in Pennsylvania, has an area of 401 square miles. It is characterized by rugged topography and heavily forested land — 97%. The highest point of 2,380 feet is between Cooks Run and Havens Run; the lowest of 740 feet along the Sinnemahoning Creek. Local names reflect early settlement by Indians, and abundant evidence of Indian occupation has been uncovered.

A road built up the West Branch and the Sinnemahoning in 1806 by the Holland Lumber Company became a highway for pioneers going west. Early settlers came from eastern Pennsylvania, New Jersey, the New England states and the eastern provinces of Canada. They were hearty, rude, courageous and honest, delighting in rough practical jokes, and feats of adventure with hazard and danger.

Due to the topography, areas suitable for settlement are limited, and county population has remained low and stable, 4,273 in 1870 and peaking at 7,644 in 1910. In 1990 the population was 5,913.

Early industry included logging, farming, coal mining, hunting and trapping. The dense stands of white pine in the county accounted for much of the lumber taken from Penn's Woods. In the late 1800s manufacturing became important. Hamilton Curtis Company opened a tannery in 1866. In 1868 coke ovens and an iron furnace started operation. The Climax Powder Plant was built in 1890, launching additional dynamite production companies which continued until 1931. Cameron County dynamite opened the Panama Canal. In 1906 C. B. Howard & Company moved the Novelty Incandescent Lamp Company (NILCO) to Emporium. This was the beginning of Sylvania, headquartered in Emporium

until the early 1980s. Pennsylvania Pressed Metals (now Sinter Metals Inc.) was started in 1965 and is now the largest employer in the county. Powdered metals and lumbering are the main industries existing today.

Tourists come to the county for hunting and fishing, hiking, snowmobiling, camping, and pleasure driving on the back roads, built by the Civilian Conservation Corps in the late 1930s, to view wildlife, including elk, or to just enjoy the natural scenery.

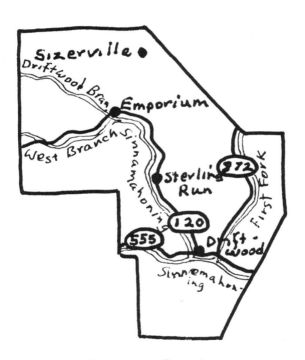

Cameron County

One with Nature

by Nelson Haas

I can't say for a certainty that the entire community residing in Cameron County today is immersed in the traditions of the wilderness, but there are many, and those who do not choose to seek out the wilds of this region are nevertheless in constant realization that beyond the bounds of the town in which they live they are surrounded by wooded hillside upon wooded hillside upon wooded hillside, interrupted only occasionally by a stream or possibly an isolated stretch of highway. Since white men settled here, many came because in their hearts they desired the remoteness, the hardships and the challenges of this kind of existence. This is the culture of Cameron County of which I write. The culture of the wilderness.

In this tradition, I find myself — a modern-day example of the independent woodsmen who came before me; those who cannot quite explain how or why they came to the big woods; those lovers of nature who not only can tolerate the seemingly hostile environment of the outdoors, but who seek it out in every facet of their existence. In their occupation and in their leisure they choose a lifestyle of being "one with nature."

Hearing the Owl's Word

This way of life is sometimes explained as a tradition, but I feel that it has been passed down from generation to generation through an ancient and primitive gene which we all possess, but which only a few can act on. The same gene which in birds gives them the ability to build nests, not having been taught

by their parents to build nests. The same gene which in humans gives us goosebumps, to fluff up our fur for better insulation against the cold although we are no longer covered with fur. Those of us who have not been completely numbed by today's modern way of life can still feel within them the way things were. To these people, the earth from which they came speaks to them, the rocks and trees call out to them from within. They shun the falsehoods of modern society and find the truth in nature.

A funny thing happens to people who have accepted nature as truth. Nature accepts them. It is a passing and a rite. When one has accepted nature it brings a certain peace and joy not found in an artificial modern world. But when nature has accepted you, it brings about a most religious feeling of being a little closer to God. Nature now protects you. Nature uncovers some of her most guarded secrets and speaks to those she has chosen as worthy of such knowledge. Emily Dickinson, in one of her early poems, describes most this circumstance when she writes:

I never spoke to God
Nor visited in heaven:
But certain am I of the spot
As if the chart were given.

As time passes, it seems this close communication with nature becomes lost or covered up with the truths of survival in the modern way of life. We see as fiction the stories of the early Indians' closeness with the natural world they lived and survived in. The fact that an owl brought them a message or that they were capable of taking on the attributes of the bear seems impossible today. But was it not so, back then, before the artificial world buried these skills? Did not the Indian depend on nature for his very survival? I think it was possible back then, and I feel it is still possible today.

How does modern man revert back to these truths

and hear the teachings of the owl over the din of today's technological racket? Let me tell you of my own experiences in these outdoors, of how one can know the truth and can hear the pure utterances of the earth itself.

The Path to Cameron County

I had a good beginning in nature, for I was born and raised on a farm. Close to the earth and to animals and dependent on them for survival and livelihood, I spent many days barefooted in tilled fields, absorbing through all my senses the truths of nature. As a child, I sat many hours in the hay bales surrounded by cats and dogs, learning their ways. Animals were dependent upon me for their food and water and shelter, and they spoke to me often of their needs. Nature was speaking to me early on, in a most practical sense, and its importance back then was not quite appreciated by a young child.

I think my first step toward this acceptance of nature was guided by my mother, who instructed this small frightened child during a thunderstorm that it was God who sent the thunder and lightning and there was no need to fear it. More, one should accept it and respect it as a product of nature from God. Ten years later, still a child but in Viet Nam during the monsoon season, I was walking through a puddle of water somewhere up around the demilitarized zone when I was struck by lightning. Sparks issued from my right knee and both hands and I was driven down to my knees in this puddle of water while several companions looked on in disbelief, wondering why I hadn't fallen over yet. I soon came to, no worse for the wear but with a renewed respect for this thing sent by God. In a not so subtle way, I imagined that God had not seen me on my knees enough during this horrible war and that I needed to be reminded that he was still in charge: .

that, with a thousand different technical ways to be killed or blown up, he could still take me out with one powerful blow. But God was kind to me.

Another lesson learned in war was that nature could protect you. Trees and foliage could hide you from those who sought to harm you. The darkness of night could make you invisible to your enemy. The earth itself could shield you from the impact of rocket and mortars. The mother of all natural things, the earth, rock and dirt, shielded me and protected me many, many times. I grew fond of the smell of the earth, the way it felt over me and under me.

Coming back home, I found my regard for nature had been only heightened and intensified. I respected nature. I walked as if in a church when I entered the woods. Loud voices, music or machinery were unacceptable there. Litter and other disturbances to the earth were an abomination. When I traveled, no one could detect my crossing. Where I camped at night, no one could know I'd been there. I camped overnight in the winters at ten to fifteen degrees below zero, not once cursing the cold of the night. I slept under storms and never once ever thought of complaining. I've been bitten by every insect that inhabits the wilds, been scratched, dented and bruised by my close association with all that's nature without ever a harsh word. And, mostly, I traveled alone, for there were few who could or wanted to follow such a path.

I learned the names of over 350 wildflowers growing there. During my hunts for the rarest of these treasures, I found that my feet were no longer being guided by my conscious thought. I found myself being led by an unknown inarticulate force. The slightest, rarest and most beautiful wildflowers fell under my gaze, and not through my own intelligence. Sometimes an unknown disturbance, a sight or a sound would drastically change my course while walking in the woods,

and there, to my astonishment would be a new treasure to add to my enjoyment.

In due time, I learned to trust this direction. I now go to the woods without plan or destination and simply allow myself to be guided. It dawned upon me that

Potter County Historical Society

The forest.

nature has now accepted *me*. I had passed the test. Nature has found me worthy of some of her secrets. It was a revelation, a gift unknown to most everyone else I knew. It put one on a different plane. Soon I started to believe the old Indian stories and sought a message from every owl I encountered. If, while sitting under an oak tree, I'd hear a disturbance in the leaves off to my side, and I'd look over to see a vole or a shrew who had stopped for a brief moment to gaze up at this creature who took up space under his oak tree, I'd find myself asking this small creature: What? What message is it you have for me from your world under the leaf of the forest floor; for I am not here by chance and neither are you, therefore our meeting must have meaning. But what is it?

At these times, when I'm in direct contact with that ancient and fascinating gene passed on from the time of creation, I can sit upon a rock and feel that I was there during its formation. I could pick up a fossil at my feet, hold it in my hand, gaze at it, and I'm back there, along the shores of the Great Devonian Sea where it had been buried 300 million years ago.

Two years after the Viet Nam War I found myself in the uniform of the Pennsylvania State Police and by the providence of those-who-be, I was assigned to Troop-K, Philadelphia, about as far from nature as one could get. After five years, when I was allowed to request a change of assignment, I looked at a map of Pennsylvania and placed my finger smack dab in the middle of the biggest patch of green I could find and said, "That's where I'm going to transfer to." I lifted my finger and under it was Cameron County. I'd never been to Cameron County before and was taken by the sheer beauty of the wooded hillsides upon my first arrival here.

Search and Rescue

As a peace officer I was appreciated as a necessary evil for the maintenance of an orderly society. A necessity who at times issued traffic citations and arrested you for being drunk and disorderly. For true acceptance, I felt I must escape into the wilderness, for there I was at ease.

Fortunately, my line of duty led to almost daily forays into the woods. Accidents and crimes occurred in the woods. Criminals took to the woods in flight, and people got lost in the woods. I ended spending a lot of both on-duty and off-duty time in the forest, often searching for lost or wanted people who by chance or choice secreted themselves in the forested hills of Cameron County.

A lost person, especially one lost in 400 square miles of wilderness, was a challenge to me. I got very good at finding lost persons with the help of some basic search strategy I received from an Inland Search and Rescue School, sponsored by the United States Coast Guard and The U.S. Department of the Interior. I was taught to utilize the wilderness skills I already had, putting them together into a successful search strategy. Since then, I've been in on every search in Cameron County since 1978, except for the five or six which occurred while I "was out of town". I've become a wilderness search expert and have been called to searches throughout the state, and at the time of this writing, am the president of the Pennsylvania State Search and Rescue Council.

Most of the lost person incidents in Cameron County have been lost hunters. An eight year study of these cases has revealed that there are three major reasons why hunters (and other persons) become lost in a wilderness environment. First, the novice outdoorsman forgets time and distance, and travels too far for the amount of time until dark. Second, two

people may become separated and each start looking for the other until both are lost. And third, the weather, such as heavy fog or fresh snow, covers up familiar landmarks, changing a familiar woods into an unfamiliar situation.

One of my early searches for a lost hunter had a surprising twist that was dramatic enough to make the *National Inquirer.* I had just gotten home from my last training session when our Search Manager, District Forester Robert Martin, rang. He reported a man had been hunting turkey in the Cooks Run area and had not returned to his vehicle. Cooks Run is one of the longest, most isolated drainages in the county, on the southeast side of the Eastern Continental Divide. The highest point in Cameron County is at the head of the Run.

I loaded my eighteen month old bloodhound Thunder into the truck and headed for the District Forest Office. After checking the topographic map I spoke to the lost subject's companion. He pinpointed a point-last-seen on the map about one and a half miles up the drainage. Another forester, Donald Stiffler, Thunder and I would walk up to this point while a forest vehicle would drive in from the top. This tactic, a "hasty search", is usually very successful in Search and Rescue, many times ending the search in short order.

This was my back-up's first search, and I explained to him how our walk was to be well within the statistical search area and in the highest probable subjective search area. I bragged to my partner that he and I would walk up the drainage, yell one time, and get an immediate audible response from the lost subject, without having to even start the hound. And that was close to what happened, but that wasn't the story.

We arrived in the dusk at the parked pick-up truck where the lost hunter's companion was sitting. I

chose a hat he had worn earlier in the day for a scent article, bagged it, and handed it to my back-up. We entered the gate at the bottom of the Cooks Run drainage on a narrow jeep trail. Thunder was enjoying the varied scents of numerous hunters which had traversed this trail on the first day of Pennsylvania's fall turkey season.

We had walked less than a quarter of a mile when a loud male voice shattered the silence of the woods. I looked at my back-up and asked, "Did he say HELP?"

We double-timed it to where it seemed the call was coming from, to the top of a twenty foot bank. "Are you injured?" I yelled down.

The reply came, "Just get down here!"

I had walked up on many terror-struck hunters in my work, and one lost bear hunter I had awakened at three o'clock in the morning pointed his empty Remington at me and pulled the trigger. The tone of voice of "Just get down here!" was not reassuring.

When the beam from my flashlight hit the lost subject, I saw a big man, in his forties, with a large six-point whitetail deer in a scissors-lock with his legs wrapped around the deer's neck, holding the head in a bull-dogging fashion. The forest floor was scraped clean down to dirt in the area surrounding them. The man was bleeding from the mouth, and his pants almost ripped completely off.

I said, "Let go of the deer and we'll get you out of here."

"No way!" he replied. "Everytime I let go of him, he attacks me again. Tie his legs down!"

I couldn't safely shoot the deer in this position, so I tied Thunder to a tree. Neither Thunder, my back-up nor myself was sure of what was going on here. I took Thunder's 25 foot trailing lead and managed to get the deer's two hind legs tied together, which only made the animal more angry. He kicked me over

backwards and I grabbed the end of the lead and cinched his legs off to a nearby tree, suffering a few rope burns in the process. I then went to work untangling the victim from the deer's antlers.

He had a hard time releasing his death-grip on the antlers, but soon we made the transfer in true championship wrestling style. Don helped the victim away from the danger as I quickly learned the art of deer wrestling. I discovered that if you twist a deer's head 180 degrees, he lays right down and kicks violently.

My back-up came back and reported that the victim didn't look too good, and he called medical personnel on the radio. Another tag-off was made and my back-up took over so I could tend to the victim. At this point, the deer kicked his legs free, and although we were going to attempt to humanely release the animal, his attitude changed our mind. If we released him, he could attack the victim again, one of us, or most importantly, my hound. So while Don held the deer's head, I dispatched the animal with my revolver. After the sound of my shots echoed off the mountain sides, all was again quiet in the stillness of the forest night.

A medical team soon arrived and evacuated the victim. He was taken into surgery, received numerous stitches in the face and groin, and was released in the morning.

We stood by awaiting the Game Commission Officers who, I was sure, would want to investigate this one.

As it turned out, this deer had been found as a fawn and raised by someone thinking it was "abandoned." It had no fear of humans, and when the rutting season came, it saw the hunter as an additional potential rival with whom to fight. This type of aggression is not unusual in "tame" deer. After an unsuccessful day of turkey hunting, the hunter had been approached by this frisky buck. Sensing trouble, the hunter hand-fed

a round into the chamber of his rifle. He never got the bolt closed before the buck had his antlers in the rifle's sling, and a four-hour battle between man and deer was underway.

Man-Hunting

One of the basic principles learned about wilderness search and rescue is that no one can traverse a wilderness environment without leaving clues. This is why the experienced searcher looks for clues and not for lost people. You become "clue conscious", for there are thousands of clues, but only one lost person. If a searcher is taught to look for the smallest clue, a footprint, a disturbance, or a dropped item, he will surely not miss a large human.

Man-tracking is a lost art in today's society, and a lot of other searchers and I have begun using man-trailing dogs to find lost persons. Trained dogs can detect human odor hours after a person has passed. Today, human odor is the most important clue left by a lost person.

There are a lot of myths about what exactly is human odor. Hunting supply outfits sell preparations to cover up human odor so hunters are not detected by deer or other game, but if you truly understand human odor, you know this is an impossibility. A trailing hound has a larger nose than humans, containing more olfactory cells, meaning a greater ability to detect many odors at one time. When we as humans enter a forest we only detect the sweet, fresh odor of a forest, but any animal whose primary sense is his nose can detect hundreds of odors. He can smell and differentiate the decomposition of twenty different varieties of foliage, what animals are present, and what animals have passed through in the last several days.

Human odor is provided by the hundreds of thousands of human cells we constantly are shedding, the

same dead skin and hair cells we attempt to rid our-
selves of by bathing, for upon their death they are
immediately attacked by bacteria who consume them
and emit methane gas as a by-product, the offensive
human odor. People use perfumes to cover up this
odor, but a scent discriminating animal would simply
smell perfume mixed with methane gas from decom-
posing cells.

Some old black-and-white movies showing baying
hounds on the trail of a prison escapee suggest that
changing shoes, putting pepper on your trail or cross-
ing water may disguise human odor. Not at all. The
human cells we shed do not come from our feet, but
are carried around our body in a convection current
and rise in a stream of warm air to a point approxi-
mately eighteen inches above our heads, where they
cool, and fall to the ground and become lodged under
leaves and rocks, in the cracks of sidewalks and in the
grass. Here they remain for several days if the condi-
tions are right until they are entirely consumed by the
bacteria.

While tracking criminals I appreciate these miscon-
ceptions, for they waste a lot of the run-away's time
and have a tendency to make him over-confident and
easier to find.

On one such trail, I tracked an escapee from an
adjacent county jail. I started the trail about eighteen
hours after his escape and four days later I was ap-
proximately two hours behind him, when he stole a
car and drove it to Ohio, where he was eventually
captured. Early in the evening of the third day, Thun-
der and I were on a good fresh trail leading down a
railroad track almost twenty miles from the prison. I
could see fairly fresh footprints on the railroad ties and
I felt we were close. The possibility of ambush was
real as we entered a deep cut in the railroad grade.
Night time was falling. Eventually in total darkness we

came to a highway crossing where the trail led down a township road running parallel to the railroad tracks, doubling back towards where we just came. The trail came to a large culvert pipe and Thunder entered. Not I, I must admit. Thunder soon came out in a fit of sneezing and snorting, shook his head and continued on trail with a renewed enthusiasm I could not quite understand. My backup investigated and found that the fugitive had spent some time in the protection of this pipe, probably napping, and had deposited the contents of a box of black pepper upon his departure in an attempt to throw off the dogs. His attempt had the opposite effect in that it merely cleared the hound's olfactories and he became a better sniffer.

We continued down the trail, passing several farms and hunting camps. Out of the unseen darkness ahead Thunder suddenly pulled me up a private driveway to a summer home with a broken door. Thunder and I backed off, waiting for the backup. When the place was finally searched, we found the convict had already departed. In his arrogance he had left a beer on the kitchen table with a note attached saying: "Have a beer on me, Jack." Jack was the State Trooper, my back-up. It's a scary feeling to know that at some point over the preceding three days we had been close enough to the escapee for him to recognize the State Trooper who was with me.

On manhunts you sharpen your outdoor skills out of a great desire to live to the next day. I listen out ahead for the message from nature: the snorting of the deer, the call of the jay or crow saying, "He's here! He's here!" The sounds of another human traveling through the wilderness ahead of me, the slightest brushing against a branch, the unmistakable breaking of a twig shout out to me from the normal hustle and bustle of noises coming from the woods. At times like these one sorts out fact from fiction. Where truth

spells survival. Where, if one would rely on urban intelligence, one would soon perish. It is during times like these that I let go of my modern ways of thinking and revert to forest ways. Now I am part of nature and the fugitive before me an intruder without these necessary skills, and soon he is mine.

I've grown to enjoy man-hunting. It's the ultimate game, especially if you are good at it and are usually on the winning side. Whether it be a search for an armed fugitive or looking for a lost child, it is the same game.

But nature is not a game. As my mother said, nature is a product of and gift of God. The forest, the animals within it and their struggles for survival are part of nature, and like the lightning, we do not control it. We accept it, and listen for the voice of the owl and the comfort of the dark.

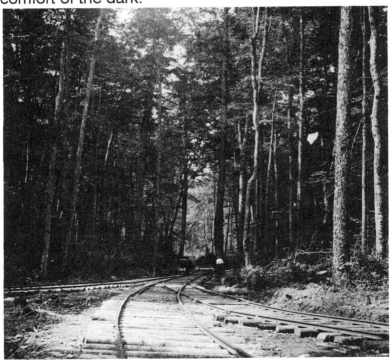

Potter County Historical Society

Chapter 12

Sullivan County Overview

Sullivan County today is very different than it was a hundred years ago. Then its population of about 14,000 was separated into distinct geographical, ethnic and cultural areas. Most residents were self-sufficient family farmers or worked in such industries as lumbering, milling, coal mining and tanning.

Beginning in the 1880s, Eagles Mere, in particular, gained fame throughout the East as an ideal place for the well-off urban family to spend the summer in a healthful and scenic rural retreat. Surrounding a natural lake on top of a mountain, the five large hotels and many elegant Victorian "cottages" provided an environment of gracious recreation and relaxed but genteel living. Guests arrived by train or motor car for a weekend, a month, or a whole season of swimming, golf, tennis, dancing and formal dining. Although the hotels had closed by the 1970s, much of the atmosphere of an earlier time still lingers.

Today slightly more than 6,100 people live in Sullivan County, and about one third of those employed work outside the county. Local employments include dairy farming, lumbering, minor manufacturing, retailing, public service, and jobs connected with tourism. This last is especially significant since about one-third of the county is owned by state agencies and used for public hunting, fishing and other forms of recreation. Of the private property, 58% is owned by non-residents. Land values are the highest in the Northern Tier, and in the summer resort populations triple or quadruple during June, July and August.

Other ways in which today's Sullivan County differs from that of the past are in the ages, the relative poverty, and the increased unity of the residents. Almost one third of today's population is under 20 and about the same proportion over 60. Low prevailing wages combine with these age cohort distortions to produce the lowest per capita income and highest poverty rate in the area. Sullivan County has become considerably more unified due to three factors: the consolidation of schools in the 1960's; increasing ethnic and geographical intermarriage; and expanding roles played by county governmental agencies.

Today Sullivan County is a good place to live with attractive

scenery, lots of space, a low crime rate, good schools and public services, and friendly people living in single family homes in small towns, but it is a hard place to make a living. More than 58% of its high school graduates go on to further education or training, but most of them settle elsewhere.

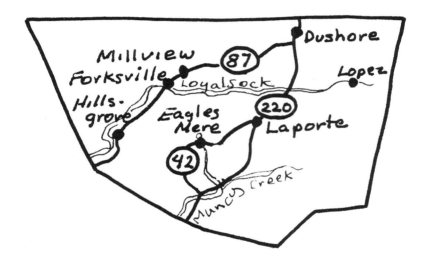

Sullivan County

The Millview Quilters of Sullivan County

by Ruth Tonachel

From July until November of 1992, I spent time on and off with a group of quilters meeting in Millview, Sullivan County, Pennsylvania. I was a "field-worker/folklorist," part of the team documenting the state of traditional arts and culture in the Pennsylvania Northern Tier. This is a report of that experience.

How the Quilters are Organized

The Millview Missionary Society quilters have been meeting for over 100 years. The present group sets up their frames in the basement of the Millview Wesleyan Methodist Church, two miles east of Forksville. The nine members meet every Wednesday from 9 a.m. to 2:30 p.m. and finish a quilt every two to three weeks. No record of the completed quilts has been kept and the money taken in is given to support the church missions work.

While there are quilters' groups scattered across Pennsylvania, this group is unique in its longevity. Members now in their eighties remember their mothers participating in the group, although, "back then, they only met once a month and it was at someone's house," says Grace Norton, the primary spokesperson for the group.

The 1970's revival of quilting led to more work for the Millview group and some new members, but it is not a group that is swayed by new trends. While some members do attend workshops and quilt shows and read books and magazines on the subject, they are not "competitive quilters." Their aim is to enjoy them-

selves while doing something useful and productive, not to complete letter-perfect quilts. This is not to say that there is anything second-rate about the quilts that are done in Millview, but that somehow the act of doing and being together is at least as important as the finished product.

Quilts come to the Millview group from all over the state and, occasionally, the world. Never advertising, the group has a steady supply of tops to quilt provided through word-of-mouth publicity. They suspect that some are sold for high prices in Lancaster County. Many are brought in to be quilted as wedding, anniversary or baby gifts. They know that some of the

Patricia M. Macneal

The Millview Wesleyan Church, Sullivan County. The quilters meet in the social room below the sanctuary.

quilts have gone to Japan, England and other foreign nations. Bessie Brown tells about a quilt made a number of years ago by the Millview quilters that is in a museum in Turkey.

The group ranges in age from about 50 to 87 and is representative of Sullivan County in many ways. Most members have spent their whole life in the county. Of the four that are not lifelong residents, two, Alice Huff and Freda Cilvick, were born and raised in the county but left for extended time periods and then returned. May Norton, an Ohio native, married a Sullivan County native and they retired to the county after 40 years in New York City. Lynn Tooey is a transplant from the Philadelphia area who had vacationed in the county for over 20 years.

In general, retirees and vacationers make up a larger and larger proportion of the residents of the county. In Sullivan County, over half the land is owned by non-resident owners, some of whom are the children and grandchildren of the Millview ladies. Many hope to retire there. "Coming home," is a recurrent theme for many people who have roots in the county.

The Leadership Team

The primary spokesperson and organizer for the Millview group is Grace Norton. An amazingly young and vibrant octogenarian, Grace is a retired teacher and descendent of the first permanent settler in Sullivan County. Raised on a farm just across the road from the Wesleyan Church, she exudes a warmth and enthusiasm for life that seems boundless. Her memories and descriptions of life in the early 1900's are full of the fun times and community spirit that she still keeps alive.

Grace taught for 30 years in the county, starting with grades one to eight in a one-room schoolhouse at Elkland and ending with first grade in the consolidated school at Laporte. She attended Mansfield

State Teachers College after high school, although, "in those days, you could teach with just a summer course after high school." As she is quick to tell you, things have changed. "Back then, you had one friendly visit a year, in the spring, from the superintendent. Otherwise you were on your own and you just did what you were supposed to do."

Grace learned to quilt at home, and her mother was a member of the Millview group. She herself has been actively involved with the group for about 20 years. Grace makes many of the quilting patterns used by the group, although the decisions about which quilting pattern to use or how to put a top together are made by the whole group.

Alice Huff is one of Grace Norton's former students. At 69, Alice is one of the younger quilters but age is a

Grace Norton

Grace Norton as a teacher in her younger days.

nebulous and irrelevant quality in this group. With her husband, she is now the owner/manager of the Millview Motel. However, Alice left the county 50 years ago to go on to school. She married a man from Bradford County and though they lived "away" for many years, "he never liked New Jersey." Alice is also a teacher, and continues to substitute, but returned to Millview and bought the motel when her husband retired in 1988.

Alice is active in many community groups and does basket-making, caning, macrame, huck-weaving, knitting, crocheting and tatting, as well as quilting. She is committed to recycling and tries to find a use for everything at the motel from old sheets to shower curtains. A woman with strong opinions, Alice often brings new ideas and techniques to the quilting frame.

A Tie to the Past

Bessie Brown is the oldest member, but again, age can be deceptive in this group. Bessie has been a widow for almost 50 years and she feels strongly that the community around her made it possible for her to raise her four children and survive the loss. Like Grace Norton, Bessie is a descendent of the Molyneux family—along with the Bird family, two of the first three permanent settlers in the area. Bessie's husband was from the Warren family, the third of the original settlers.

Now established in nearby Forksville, Bessie grew up on a farm above Millview and she has worked at various kinds of jobs in her lifetime. Her mother was also in the Millview group and she herself has quilted "as long as I can remember." She has given away 24 quilts to grandchildren, and made many others as well.

Like Grace, Bessie has fond memories of the past

when farming was the primary industry in the region and "people made their own lives." She is concerned about the influx of tourists and vacationers and feels that "farm consolidation has ruined the community spirit." Grace Norton adds, however, that there were always vacationers in the county, but "they used to come for two or four weeks and stay in someone's home or on a farm. Or they'd stay at the hotels in Eagles Mere, and local girls used to work there as waitresses." Now people are likely to buy land and build a cabin or summer home of their own.

While she doesn't like the kind of settlement occurring, Bessie mentions that there were actually *more* people in Sullivan County in the early 1900's. "There used to be a lawyer and three doctors here in Forksville," she says. Now she travels to go to the doctor, to her a substantial distance.

With automobiles and decreased rural population has come consolidation of services. Grace and Bessie observe the same trend with schools; there used to be many small schools that children walked to, but there is now one school and a lot of busing. Bessie mentions her daughter who felt that she got more education during her six years in a one-room school in Sullivan County than when she moved away and went to a more "up-to-date" high school in Montoursville.

Most of the group echo fears about the changes in their county. They like knowing neighbors and feeling safe, but all say they have to lock their doors now and that the crime rate has risen noticeably.

The Hottenstein Girls

Frances Fetherbay and Lillian Ayers are sisters and, though in their seventies, are still referred to by some in the group as "the Hottenstein girls." Born in the Pittsburgh area, they came to Sullivan County as

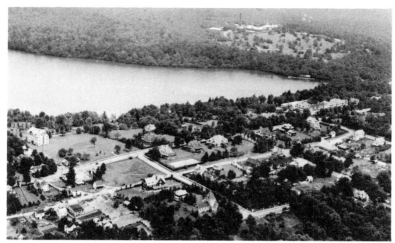

Sullivan County Historical Society

Eagles Mere in the late 40s.

toddlers when their father decided to come "back home." Reared on a dairy farm, both worked hard there and then went on to work in local industries.

Lillian retired after 26 years of making box lids for the Rynveld Wreath factory in New Albany. Frances retired from a men's pajama factory in Dushore where she had been a sewer for ten or so years. Both factories are now closed. Lillian says she liked her job but "didn't get enough pay and there were no benefits. It was close to home though." Rynveld's was never unionized. She says "a union *would* have improved it but they never got it in. They tried." Frances says the same of the pajama factory; "People tried, but they didn't get it in."

Of Austrian/German ancestry, both Frances and Lillian are quiet and hard working. Lillian's daughter Carol Benjamin is a local quilter who sells quilts and needlework from her Overton area residence. Lillian and Frances have a son and a daughter each, and all four offspring still live nearby. One of Lillian's grand-

daughters is married to the son of another Millview quilter, Grace Treaster.

To Baltimore and New York and Back

Freda Cilvick lives in the Overton area near Frances and Lillian. Freda worked at the Endicott-Johnson shoe factory in Mildred in the 1940s and 50s as a floor lady in the stitching department, at $ 65 a week. "It was stressful but I liked it." The factory closed in 1991.

In 1957, Freda and her husband moved to Baltimore where her husband worked as a police officer and Freda worked in department stores. In 1969 her husband, who died in 1981, was badly beaten and disabled, "by a drug pusher who was 23 years old, had 13 convictions and was out on parole," according to Freda.

In December, 1969, the Cilvicks "came home" to Sullivan County. Freda has two sons who are truck drivers in the county and a daughter close by. When asked how long she has been quilting with the Millview group, Freda said, "oh, three or four years." After some discussion, the group concluded that she had been coming for over ten years. It was clear that the saying, "time flies when you're having fun," applies to this group.

May Norton, in her eighties. is married to a cousin of Grace's husband. A native of Newark, Ohio, and a registered nurse, May worked in the delivery rooms and nurseries of several hospitals in New York City for 30 years. When she started in 1931, May said she worked "very long hours" (Sometimes 18 hours a day) for her board and $75 a month. During World War II, May was not employed in nursing for a few years and did volunteer work. She knitted 29 sweaters for the war effort and learned to repair knitted and woven items that were donated by others.

Although she learned to quilt at home, May did not

use that skill again until she came to Sullivan County. She has been a member of the Millview Quilters for 20 years. She has no regrets about moving from New York to rural Sullivan County and says what she likes best about the community is "the people here."

The Youngsters of the Group

Lynn Tooey is the newest member of the group and the only one who is not related to anyone else in the area. She and her husband bought property along the Loyalsock Creek about 28 years ago. He came up from their Philadelphia area home to hunt. In 1989, they moved to a home up the hill from Millview. When asked what she misses most about her former home, she has to stop and think and finally says, "Shopping, I guess. It's a half hour to go for anything so you have to plan more here. But, overall there are a lot more pluses here than minuses."

Lynn learned to sew from her mother and has been quilting for over 20 years. She joined the Millview group about a year and a half ago. Formerly an x-ray technician, Lynn is the youngest group member but says she enjoys hearing about how things were and doesn't feel left out by age or lack of local relatives because the others make an effort to include her in the conversation.

For Lynn, as for several of the other women in the group, this is her primary social activity. Although she attends the Catholic Church in Dushore, she feels it is too far away to participate in other activities there.

Grace Treaster is in her mid-seventies and grew up on a dairy farm nine miles outside of Dushore in Forks Township. Her husband, now deceased, was also a farmer and she has three sons. One works in Laporte as a mechanic but the other two have left the county.

Grace joined the Millview group nine years ago and learned quilting from her mother. She never worked

off the farm. Both Grace and Freda Cilvick are cousins of Red Grange, an early national football hero who hailed from Forksville.

Shared Values

Among the group, Lynn and Freda are Catholics, Grace Treaster is an unaffiliated Protestant and the rest are members of the Millview Wesleyan Methodist church where they meet. Alice Huff says she joined the Wesleyan church, "because I can walk to it."

A majority of the women are widows and this accounts, to some degree, for the loyalty they feel to the group. Grace Norton jokes that they talk about buying a house and moving in together since they all get along so well but says they could never find one big enough. When pressed, however, she and Freda admit that they don't really want to live with anyone and have gotten used to being on their own by now.

As their guest, I was impressed by the consistency of the group and the peaceful, warm atmosphere of cooperation that prevailed. Few of the women ever miss coming and, as a result, the volume of work completed is impressive. There is a flow of conversation that went on despite my questions and the intrusion on October 7, 1992, of a video camera and crew. I always felt welcome and found that even on days when I had other worries, just being with the group provided a sense that things would work out.

Invariably, when asked, all of the women mentioned friendship and the others as their reason for coming. Bessie Brown said, "Well, the sewing, of course, but it's the association with the other members that's the main activity." Grace Norton said she comes, "because we have fun," and Lynn Tooey mentioned, "the friendship, seeing everybody and coming every week" as important factors. She said she likes to "know it's here every week." The weekly potluck style

lunches were also mentioned by most as something they look forward to and enjoy.

Frances Fetherbay said, "I come to get together, to visit. We like to quilt...but it's nice to get together," and her sister, Lillian Ayers, likes the group because they are friends and "there's no bad language here."

It is clear that there is a bond within this group that extends to include others who join or even those who just visit. Over the years, many other women in the county have participated for weeks, months or years, depending on their stage in life, employment demands, child raising status or other factors. It is probably the sense that they are part of an ongoing tradition that gives the group a sense of stability in spite of new members coming and going. But it is also some older sense of community and shared history that brings these women together to work and to create lasting artistic works that are traditionally American. Their weekly gathering provides something that "support groups" of all kinds try hard to emulate but usually can't reproduce–true interaction, listening to each other, sharing food and lives and doing worthwhile, productive work for the good of others–all at the same time.

Melva Calaman

Pearl Short, age 15, with her cousin, Etta Short (Swart), age 6, in the woods in Hammersley Fork, Clinton County, about 1900. Etta's father was a logger, and Pearl—later Bonelyn Kyofski's Grandma Hess—was the daughter of the hotel owner.

Chapter 13

Other Voices, Other Times

by Bonelyn Kyofski

The fact that the reader may never have heard of the Pennsylvania North Country in his life does not mean that those who lived here have never before taken pen to paper to try to tell the greater world about our local ways and circumstances. We can no way make a complete acknowledgement of the people who have documented and are presently maintaining our history and literature. However, we can make some generalizations. Most local writing that appears in public view is in the genres of lyric poetry, occasional memoir, and newspaper columns that, whether in conservation notes from the professional woodsmen, in local history features from a variety of devoted raconteurs, or in commentaries by our philosophical humorists, present our genuine vital folklife. Other local writers, fewer than those mentioned above, have written books about the area, and yet others have been influenced by it.

Local Writers

Much of the most alive prose of our region is the ongoing commentary of editors, publishers, and feature writers, present and past, of the local weekly newspapers. Occasional lucky towns have books published recounting regional lore by these folk — the Heimel-Metzger, Stoddard-Watkins, Goodrich, Frazier, Currin, Pepero, Bailey, Wilson, Swinsick, Frazier, Lawrence clans.

These writers have been contributing articles on events and people — interviews, reflections, research projects — to the local newspapers for many years. Bill Bower, one of our Bradford County foresters, has written several books of his experience in the woods, the most notable named *The Man in Green.* Arnie Hayden, animal protection officer and woodcrafter, has written features on wildlife for many years as well.

Historians and Folklorists

Knoxville's notable author-historian is Edwin A. Glover (1907-1996), a practicing attorney until his death this spring. Ed wrote several local histories; his *Bucktailed Wildcats* (New York, 1960) is an impressive account of our famous sharpshooting northern Pennsylvania regiments of the Civil War.

Our folklore is history here. Of course, Ed dealt with the Wildcat name in the book:

"The Wildcat District had no definite boundaries. One might say it included that part of Pennsylvania generally north and northwest of Williamsport. It was inhabited by the feline variety of wildcat, but that fact had not given the area its name. The rough, hardy lumbermen of the northern counties made annual rafting expeditions down the Susquehanna to get their timber to market. They were a wild, boisterous lot and particularly so on the homeward trek overland. Their antics in general and their occasional brawls in particular earned for them and the section from which they came the name of Wildcat. The Wildcats had grown to be somewhat proud of the name.

"There is another tradition as to how the area got its name. Back in 1832 one Hiram Payne, a McKean County editor and politician, attended a caucus of politicos in Harrisburg....His then wilderness counties were not getting the recognition he thought they deserved. When delegate Payne finally got the floor, he

Other Voices, Other Times 181

proceeded to tell his downstate colleagues some-
thing about the size of the district he repre-
sented....Payne is supposed to have ended his
diatribe something like this: 'And remember I repre-
sent more territory, more bears, more wolves, more
porcupines, and more wildcats than any five mem-
bers of this convention.' And, so the story goes, Mr.
Payne's district had a new name.[1]

"The Counselor" detailed in his notes several
sources attempting to get at the precise area the
Wildcat District comprehended — all varied. It may
just be that the Wildcat Country definition is as close
as we are going to come in our defining the bounds
of our "Headwaters Region" as well. Ed was very
supportive in the work of the Cultural Alliance — a
wonderful source for stories and memories.

Another particularly noted history scholar was
Sylvester K. Stevens. Dr. Stevens and Dr. Glover were
born within a few miles of each other (S. K. in Potter
Brook) within a short period of time. Dr. Stevens,
Pennsylvania State Historian and director of the Penn-
sylvania Historical and Museum Commission toward
the end of his career in the early 70s, was widely
published as an expert in Pennsylvania History.

Then there is Herbert Stover, a historical novelist,
(1888-1963). Born on the southern edge of the region,
the son of a farmer, logger and forester, he was a
teacher, finishing his career as superintendent of the
Lewisburg public schools from 1928 to 1953. At the
age of sixty-one he began writing historical novels,
one a year for six years. *Song of the Susquehanna* tells
of the river and the frontier. *Men in Buckskins, Powder
Mission* and *Eagle in the Wind* are about the Revolun-
tion. *By Night the Strangers* tells of the Underground
Railroad in the Northern Tier during the 1850s. *Cop-
perhead Moon* is a Civil War story set in Pennsylvania.

Although born in New York, Henry W. Shoemaker

(1880–1958) is remembered as the folklorist, writer and historian who set his mark on Pennsylvania's appreciation of its folklore and history. His home, Restless Oaks, is in Clinton County, near McElhatten, and he is buried in the Lock Haven cemetery. Simon J. Bronner has recently written a perceptive evaluation of his work, *Popularizing Pennsylvania: Henry W. Shoemaker and the Progressive Uses of Folklore and History,* published by the Pennsylvania State University Press, 1996.

Our Wildlife Writer

An eye-opening discovery in this review is that of Galeton's particular author, Jim Kjelgaard. Adolescent literature is an important part of secondary education, and a revolution in the genre in the last 15 years has rejected most earlier "books for teenagers" as vacuous and unrealistic. Jim's books are among those written and achieving popularity in the 1940s and 50s, but a current reading reveals them as enormously appropriate and appealing for country kids today.

Big Red was a standard selection in adolescent literature book lists in ealier years; the well over 40 other books Kjelgaard penned were not so well-known, though his skill for "blending humans and wild animals in a genuine nature story with a thrilling plot" is cited repeatedly in reviews of his work.

His novels — of both animal and human characters living in synchrony with the land — embody a vivid irony; they strike a much more sympathetic chord today than they would have when they were written. In the 50s a motherless young man keeping his family livelihood as a hunting and fishing guide viable while his father serves a prison term for assault would be quaint; his jeopardizing his own safety and comfort to rescue a suspicious appearing alienated dog — or risking being trapped in a blizzard in order to track a

mink wounded by one of his traps and rescue it from an excruciating death — would have found scant acceptance in the throwaway age. The values the Kjelgaard characters embody, including a boy's loyalty to an imprisoned father, (in *Stormy*) are strikingly relevant to adolescents today.

Kjelgaard's books are set all over North America. He even wrote the standard young people's biography of Geronimo.[2] The common thread is the outdoors. Kjelgaard credits his life in northern Pennsylvania in his understanding of the wild:

"Those mountain farms," he remembered, "produced more rocks to the acre than anything else. But they provided my brothers and me with plenty of ammunition for fighting the neighboring boys across the creek. One of our jobs was to shoo the cows out of the cornpatch, which was more exciting than it sounds. There were always two or three yearling bulls in the dairy herd, and when we wanted to get home quickly, we'd each grab one by the tail. The bulls would light out for the barn, their feet hitting the ground about every two yards, and ours in proportion. But the really entrancing thing was the forest that surrounded us: mountains filled with game, and trout streams loaded with fish."[3]

My uncles and brothers might have said that also. In other contexts as well, Kjelgaard cites northern Pennsylvania as a "heavenly" place to grow up.

Our Local Color Writers

A non-native storyteller whose work is reflective of the North Country local color is James Y. Glimm. His wide-ranging collections, *Flatlanders and Ridgerunners* and *Snakebite*, are an entertaining combination of true characterizations and genuine folktales of the region, interspersed with jokes, general lore and legends of uncertain provenance, some traditionally

identified with southern Pennsylvania, others with other rural or mountain regions, as the title of the first book would indicate. The lack of traditional documentation of oral history leaves an outside reader with no clue as to which are authentic to the Pennsylvania Northern Tier. Nonetheless, the Glimm popularization of the original "flatlander/ridgerunner" designation, generated in the southern mountains and brought to Pennsylvania North Country recently by hunters and tourists and books, has "taken" and become our next generation's genuine folklore.

Local histories of individual churches, communities, organizations, libraries, literary groups, companies and industries keep our heritage warm and well within the region. Most are in print and on sale by the Historical Societies, at the Pennsylvania Lumber Museum, or at local bookstores. The best documentation of local history holdings in the Northern Tier to date was prepared by LesErik Achey, research librarian at Mansfield University, in connection with the local libraries, sponsored by a Bicentennial grant in 1976.

The libraries of the individual towns for the most part are linked with the local historical societies because in typical rural fashion usually the same people are involved; therefore the towns' local history collections are more than respectable. The Achey bibliography is still fairly current, and our librarians are very aware of what is available.

Norma Strait Howland, member of several several-generation Tioga County families, has written histories and has provided us with those written by others, as well. Norma is currently writing a history of the Watrous area. We hope her librarian daughter Linda Walters will formalize her work as a critic and long-time friend of the family in writing the re-evaluation of Jim Kjelgaard's work.

Heroes of Library Collections

In Potter, Tioga and Bradford Counties the remarkable association of local libraries both emphasizes and strengthens the North Country's penchant for reading. Each library has its own "special collection" of particular local characters or authors who are legendary in one way or another. The subjects are diverse, the only link geographical.

Coudersport and Galeton share an "ownership" in Ole Bull, the Norwegian violinist who planned the utopian settlement that became Oleona. Paul Heimel's book, *Shattered Dreams; the Ole Bull Colony in Pennsylvania,* (1992) is the authoritative work on the colony. Paul is a Coudersport native.

Coudersport has as well a strong claim on Eliot Ness, who spent the last years of his life there. The biography that was the base for "The Untouchables" was written in the Coudersport Hotel, according to the librarians.

Margaret Sutton, another Coudersport claimant, wrote the Judy Bolton series of adolescent mystery novels. Several sites in Coudersport are identifiable in the settings of the various books, and there is a group of devotees of Bolton who specialize in the identifications. The Bolton books have recently been republished by Applewood.

The Blossburg and Mansfield libraries have a good bit of material on Scott Nearing and on general local labor history. The first labor riots in the United States occurred at Morris Run in 1870, and there were strikes in other Northern Tier mines in the next 30 years that provoked some further national interest. Folk hero "Mother" Jones came to Arnot to help the strikers in 1900. Recent labor history is recognizing the major role of women in the movement. Mother Jones organized not only the women

and children but the surrounding farm community as well; as always, her involvement lent media interest.

National Literary Connections

Philip Young, in my eyes, even before knowing of his connection with the Northland, was the most interesting and fun-to-read American literature critic in the United States in the 1950s through the 1980s. The late Dr. Young was a brilliant teacher at Penn State, his writing characterized by humor and impatience, acute perception, and a kind of macho straightforward sensibility that made him famous analyzing Hemingway. Phil told me one day when we were discussing Sinclair Lewis and small towns that his father was born in Nelson, my own hometown — later he modified and confirmed that his great-grandmother grew up here and it was his father's "favorite place." My favorite anecdote about Phil was a report of his addressing a Modern Language Association meeting, paraphrasing Whitman, but using the kind of self-deprecating humor and style, if not content, that would have fit more typically into a Northern Pennsylvania venue than into the scholarly ambience of an MLA group in Chicago. Phil began, "Remember Whitman? 'Do I contradict myself? So I contradict myself. I am large. I speak multitudes.' I'm Philip Young. I contradict myself, too. But I am small. I speak platitudes."

Dr. Young's father kept close contacts with the Tioga County relatives until his death. Phil's Massachusetts upbringing, his work at Amherst and NYU, may have influenced him (slightly) as well, but he has North Country earmarks.

It is intriguing that Amherst crops up relatively often as the college of choice in the old Bradford and Tioga County histories. One wonders if the influence came from the early settlement patterns from central and western Massachusetts.

Another Amherst student and teacher, Rolfe Humphries (1894–1969), spent his childhood in Bradford County. Humphries is certainly the most noted poet from our area. Educated at Amherst as a scholar in the classics, Humphries taught Latin in high school many years, publishing wonderful poetic translations of the *Aeneid* (1951), Ovid's *Metamorphoses* (1955), and work of the modern Spanish playwright Lorca. He has been widely anthologized by many scholars. In his later years, Humphries returned to Amherst as a professor. His poetry indicates enormous flexibility from the measured translations and religious poems to both earthy and ethereal lyrics. His *Collected Poems* were published in 1965, and his last lyrics were published as *Coat on a Stick* in 1969.

Another North Country author whose work has achieved global recognition is Vance Packard (1914–), whose best-sellers of the 1950s and 60s articulated for Americans the striving for conformity and materialistic excess that the later sixties were to excoriate. *The Status Seekers, The Hidden Persuaders, The Pyramid Climbers* were very successful sociological commentary, and *The Waste Makers* (1960) brought the term "planned obsolescence" into common parlance. Vance was born in Granville, Bradford County.

Scott Nearing (1893-1993) was born in Morris Run, the son of the "boss" of the mines, which was, from all evidences, his last close affiliation with "management." At several points in his life, Scott achieved fame; he often had notoriety thrust upon him. A well-regarded professor of economics for nine years at the University of Pennsylvania, in 1915 he was fired for protesting against child labor in Pennsylvania factories. As such, he became the cause for the first academic freedom case espoused by the American Association of University Professors in the United

States. Despite broad support, Nearing was not rein-
stated and was fired from his next job for his anti-war,
anti-violence stance at the United States' entry into
World War I.

Scott Nearing was a socialist, pacifist, vegetarian,
radical, all rare in northern Pennsylvanians, but also
fairly tolerable in our live-and-let-live milieu. Nonethe-
less, his niece, Mary Skinner, said recently that when
her mother, Scott's sister, expressed concern over
Scott's diet on a visit to Troy, her father contemptu-
ously remarked, "Turn him out and let him graze!"
Mary, who adored Scott, implied that the disapproval
was for Nearing's politics and not his eating habits.

Scott was one of the octogenarians interviewed in
the film "Reds," as a direct observer of the Russian
revolution and the birth of the communist govern-
ment. He wrote over 30 books, mostly economic his-
tory and sociology, the later ones his vastly popular
back-to-the-earth advocacy. His most famous books
are *The Conscience of a Radical* (1965) and *The
Making of a Radical* (1972). *The Maple Sugar Book*
(1950), co-authored by Helen and Scott Nearing to-
gether, can be found in more than one maple pro-
ducer's home in the region.

Clyde Bresee (1918–), whose current book in pro-
gress is reportedly about his early Bradford County
life in Ulster, has published two extremely well-re-
ceived books about the world his family experienced
while his father managed a plantation on one of the
sea islands across the Ashley River from Charleston
in the 1920s. *Sea Island Yankee* (1988) and *How
Grand a Flame* (1992) in description are far from Brad-
ford County, but the delineations of his parents, lovely
fleeting contrasts to the North Country farm life and
the world of his Methodist grandparents make his
books familiar country for his Yankee neighbors.

Jane Roberts is the author of *Seth Speaks: the*

Eternal Validity of the Soul (1964). Seth is the spirit who inhabits her trancetime. Her many other psychic works include other material about Seth, "psychic interpretations" of Cezanne and William James, and *The God of Jane: a Psychic Manifesto* (1981), as well as non-fiction and poetry. She and her husband lived in Sayre before moving to Elmira in the 1970s.

Stretching a Point

Two extraordinarily famous word-artists knew our region, and by stretching a point we can claim them. One lived here and one looked at us — a lot.

Everyone wants to claim Stephen Foster, and we are willing to push Pittsburgh and Kentucky aside to assert that he wrote his first song, "The Tioga Waltz," while living with his older brother in Towanda and attending school in the Susquehanna Valley for a year and a half as a teenager. ("Tioga" in the waltz refers to "Tioga Point," where the Chemung flows into the Susquehanna at Athens, though the Iroquois word for "where the waters meet" is the name of two counties and two villages in the Twin Tiers of Pennsylvania and New York.) Neighboring Camptown has achieved immortality in Foster's use of the town's name in "Camptown Races."

Though it is bald-facedly "stretching" to claim any part of Mark Twain, North Country people standing where the great man's study was placed, high above Elmira, and looking at the view far across the Chemung south and west recognize the "leagues of valley ... and retreating ranges of distant blue hills"[4] as Bradford and Tioga Counties folding in upon each other. We are persuaded the view inspired some of the greatest rural American literature ever penned.

In Conclusion

Thus we arrive at the end of the present story, of the chapter, and of the book. Headwaters have found

their way to far places. The voices of the Pennsylvania Northern Tier echo in the woods.

For those who would like to explore the area further, visit the county historical societies and museums listed as an appendix to these tales. Or stop at a locally-owned restaurant in any small town to ask the location of the library, a good opening gambit for one seeking entree into a culture that looks the stranger over a bit first. Or take to an old logging trail on foot around sunset, and listen to what the hemlock and the owl have to say.

Notes

Chapter 1 — Looking Back

[1] Jim Kjelgaard, *Big Red* (New York: Bantam, 1945), Introduction.

[2] Between the time of first settlement in New England and the settlement of the Northern Tier, the Presbyterian Church grew in strength in New England. Contrary to what one might expect, there are very few Unitarian and no Congregational churches in the Northern Tier areas settled by the early migrations from New England and New York. This is perhaps due to a strong mission effort by the Presbyterians in frontier areas settled by English speaking people.

[3] Tioga, Cameron and McKean Counties all claim the Bucktail Regiment connection. Edward Glover, *Bucktail Wildcats* (New York: Thomas Yoseloff, 1960) gives a full story of this part of Northern Tier history.

John C. Heaps, *Headwaters Country* (State College: Himes Printing, 1970) identifies the Thirteenth Pennsylvania Reserves as the Bucktail Regiment.

The Atlas of Pennsylvania, David C. Curr, William J. Young, Edward K. Miller, Wilbur Zelinsky, and Ronald F. Abler, eds. (Philadelphia: Temple University Press, 1989), refers to the Bucktails as the 42nd Regiment of the Line, and describes them as red-shirted sharp shooters.

Jeffry D. Wert, author of many books about the Civil War, says the First Pennsylvania Rifles of the Pennsylvania Volunteer Reserve became the Thirteenth Pennsylvania Reserves when it was called up, and it was the 42nd regiment organized in Pennsylvania. Colonel Kane was in charge of the regiment, to which some companies from Perry and Chester Counties and other mixed companies were added, to make up the full regimental strength.

[4] Collected by Kenneth Thigpen, 1976.

[5] An original printed broadside of "The Leek Hook," dated 1866, hangs framed in the Potter County Historical Museum. It contains nine stanzas, two more than the six sung by Mrs. Hess. It is attributed to and endorsed by George Washington Sears, 1821-1890, who usually wrote under the pen name "Nessmuk." Born in Webster, Massachusetts, G. W. Sears served briefly in the Bucktail Regiment, travelled the world, wrote, and lived for his last 42 years near Wellsboro, Tioga County, Pennsylvania.

Herbert Walker, in *Pennsylvania Songs and Legends*, George Korson, ed. (Baltimore: The Johns Hopkins Press, 1940), p. 351, gives a nine stanza version that appears to be identical to the one attributed to Sears. Walker writes, "'The Leek Hook' is an example of the cumulative ballad composed of lumberjacks' improvised verses." He records it as "Sung by Wes Berfield. From *A Story of the Sinnemahone*, by George William Huntley, Jr. Used by permission."

Both the version attributed to G. W. Sears and that collected by G. W. Huntley as sung by Wes Berfield refer to the hero as a "raftsman," not "woodsman" as in the song sung by Mrs. Hess. Other words also vary. In the version on the broadside "yellow shirt" is "scarlet shirt," for example.

[6] *The Pennsylvania Manual,* Lynn S. McQuown, ed. (Harrisburg, Pa.: Commonwealth of Pennsylvania, 1995), Vol. 112, p. l-21.

[7] This oral history about the lumber camp was collected by folklorist fieldworker Suchismita Sen in 1992 as part of the Northern Tier Documentation Project.

[8] Information on the company coal town is from *The Kettle Creek Coal Mining Company and the Slovaks Who Mined there: A Narrative*, an Independent Study Project by Leonard Parucha, completed under the direction of Professor Charles

R. Kent, Archivist, Lock Haven University, Spring Semester, 1985, p. 11. It is taken from Wyndham Mortimer, *Organize,* p. 14.
[9] Parucha, p. 13.
[10] *The Pennsylvania Manual,* Vol. 112, p. I-23.

Chapter 2 — The Last Raft: A Lumberman's Legacy

[1] All of the following taped interviews are from the Northern Tier Documentation Project (Lumber Region Project or LRP), collected by L. Kenn Reagle. Hughes, (LRP), collected 3/12/93.
[2] Allison, (LRP), collected on 3/5/93.
[3] Smith, (LRP), collected on 3/11/93.
[4] Ferrell, (LRP), collected on 2/25/93.
[5] Smith, (LRP), 3/11/93.
[6] Court House testamony of John Bain inquest, p. 4.
[7] Reitmeyer, (LRP), collected 3/24/93.
[8] Hughes, (LRP), 3/11/93.
[9] Prather, (LRP), collected 3/12/93.
[10] Hoffman, (LRP), collected 4/2/93.
[11] Latimer, (LRP), collected 3/11/93.

Chapter 3 — The Kettle Creek Coal Mining Company and the Slovaks Who Mined There

[1] Frederick E. Gleim, Treasurer, *Deed Book 39* (Clinton County, Pa.: Clinton County Court House), p. 750
[2] Article of patent, Kettle Creek Coal Mining Co., *Deed Book 39,* p. 750.
[3] Wyndham Mortimer, *Organize,* p. 14.
[4] Michael Antos, *History of Bitumen,* an account written for Dr. Graydon Mervine in the early 1930s.
[5] Antos, p. 30.
[6] Mortimer, p. 14.
[7] Antos.
[8] Antos.
[9] Leonard Parucha, "Notes on Bitumen," a series of statements taken from past residents and neighbors of Bitumen and surrounding area, 1981.
[10] Leonard Parucha, "Notes on Bitumen," 1980.
[11] Parucha, 1980.
[12] Antos, p. 30.
[13] Jos. G. Rayback, *A History of American Labor* (n.d.), p. 275.
[14] *Renova Record*, April 20, 1922, p. 1. Also see Parucha, 1980.
[15] Parucha, 1980.

Chapter 4 — Cultural Pockets and Overlays

[1] Personal interview with George Klinefelter by Pat Macneal, February, 1996.
[2] David Hackett Fisher, *Albion's Seed* (New York: Oxford University Press, 1989), p. 873.
[3] *Historical Sketches of Potter County* (Coudersport, Pa.: Potter County Journal, 1976), p. 146.
[4] *Sketches,* p. 182.
[5] *Sullivan County Historical Society Newsletter,* 1994, 1995.
[6] Collected from Harry Wilcox by Kenneth A. Thigpen, 1976.
[7] *Headwaters Country,* p. 59.

[8] These articles appeared in regional newspapers such as *The Wellsboro Agitator, Sullivan Review,* and *Galeton Free Press.*

[9] *1990 Census of the United States,* Population and Housing Summary Tape File 3A, 040-Pennsylvania, 160-Wellsboro Borough (Washington DC: US Government Printing Office).

[10] Personal interview with Andrea Bennett by Pat Macneal, Summer 1992.

[11] Personal interview with Jack Fiorini by Bonnie Kyofski, August 9, 1996.

[12] *Sketches,* p. 139.

[13] *Sketches,* p. 146.

[14] See Chapter 9, "Clear the Other Side of Everywhere Aint So Far from Here." pp. 125–126.

[15] Personal interview with Louise Rugaber Chaize by Bonnie Kyofski, Summer, 1980.

[16] *Sketches,* p. 237.

[17] *Sketches,* p. 215.

[18] *Anderson's Directory and Reference Guide of Tioga County Pennsylvania* (Mansfield, Pa.: *Wellsboro Republican Advocate,* 1909).

[19] Personal interview with C. M. Heck by Bonnie Kyofski, August 6, 1996.

[20] "Sullivan County," *Pennsylvania: A Guide to the Keystone State*: compiled by workers of the Work Project Administration in the State of Pennsylvania (Philadelphia: Pennsylvania Historical Commission and University of Pennsylvania, 1940).

[21] See Chapter 9, "Clear the Other Side of Everywhere Aint So Far from Here," p. 129

[22] *History of Bradford County* (Philadelphia: Everts, 1878), p. 101.

[23] Personal interview with Josh Homet by Bonnie Kyofski, July 10, 1996.

[24] *History of Bradford County,* p. 101.

[25] Personal interview with Louise Molyneux Woodhead by Bonnie Kyofski, August 13, 1996.

[26] Personal interview with Jeanne Bowen by Bonnie Kyofski, August 17, 1996.

[27] Several Tioga County histories cover this point.

[28] Personal interview with Mamie Diggs by Bonnie Kyofski, August 16, 1996.

Chapter 5 — The Northern Tier Today

[1] This information is from Suchismita Sen's " Individual Fieldworker Report" for the 1992 Northern Tier Documentation Project.

Chapter 6 — The Craft of Riflemaking

There are no notes for Chapter 6. It is based on Summer 1996 research and an interview with Charles Gansell.

Chapter 7 — Spinning and Weaving in Bradford County

[1] James T. Lemon, *The Best Poor Man's Country* (New York: W. W. Norton and Company, 1976), p. 223.

[2] Interview with traditional quilters in Clinton County by Pat Macneal, 1984.

[3] This is the Camptown of Stephen Foster's "Camptown Races."

[4] Pat Macneal observed and confirmed in personal interviews these strong regional color preferences, which are discussed in David Hackett Fisher, *Albion's Seed,* p 140.

[5] There are other related museums in neighboring states. Massachusetts museums devoted to spinning and weaving are located in Deerfield, in North Andover (Merrimack Valley Textile Museum), in Plymouth (Harlon Old Fort

House), and in Old Sturbridge Village. In New York state are the Farmers Museum at Cooperstown, Monroe Museum Village of Smith's Cove.

Chapter 8 — A look at Three Faces: Musical Tradition in Clinton County

[1] The Black Pride movement in the 1960s was especially important in focusing awareness on the issue of ethnic diversity.

[2] Jim later sat John down at his kitchen table and gave him a retrospective lesson in Bluegrass music, pulling records from his extensive collection.

[3] Phil actually cut his teeth in Rock and Roll, but all it took to get him into the "hard-core Bluegrass thing," was a night with John and friends at the Dodee Lounge. Phil, a strong bass player and vocalist, is a jewelsmith in Lock Haven by day.

[4] Dick eventually dropped the guitar in favor of the tenor banjo.

[5] Other area Country and Western bands popular at the time included the Blue Valley Boys, Jim and Jane's Western Vagabonds, Mary June and Shorty Mays, and Brewer and Fife.

[6] SWM, WWVA, and WRVA were popular radio stations at the time.

[7] The band played the morning Farm and Home Gospel Show on WHLP in Milton, Pa.

[8] Chester claims he and the legendary bootlegger, Prince Farrington, shared a few drinks together when whiskey "was served in water glasses."

Chapter 9 — Clear the Other Side of Everywhere Aint So Far from Here

[1] I refer to Robert W. Chambers, *The Maid at Arms,* because it is the source of this information. It is not a notable book.

Chapter 10 — A Forest Heritage

[1] Diary of Laroy Lyman, in the collection of the Potter County Historical Society.

[2] Letter from Laroy Lyman while hunting in the midwest, in the collection of the Potter County Historical Society.

Chapter 11 — One With Nature

There are no notes for Chapter 10. It was written in Spring, 1996.

Chapter 12 — The Millview Quilters of Sullivan County

There are no notes for Chapter 12. It is based on field work done in 1992.

Chapter 13 — Other Voices, Other Times

[1] Edwin A. Glover in *Bucktailed Wildcats* cites as his source the 1890 *History of McKean, Elk, Cameron and Potter Counties,* pp. 16-17.

[2] Jim Kjelgaard, *The Story of Geronimo* (New York: Signature, 1958).

[3] Jim Kjelgaard, *Big Red,* Introduction.

[4] Mark Twain letter, quoted by Jervis Langdon in Robert Jerome and Herbert Wisbey, *Mark Twain in Elmira* (Elmira: Mark Twain Society, 1977), pp. 229-230.

About the Authors

Robert Currin — A retired high school principal turned historian, Bob is president of the Potter County Historical Society, and a member of the Pennsylvania Lumber Museum Associates.

Daniel Freeburg — The Director of the Elk County Planning Commission, Dan collects early painted furniture and arts artifacts. He has studied and written about industrialization and local history.

Nelson Haas — A retired state trooper and active outdoorsman, Nelson is president of the Pennsylvania Search and Rescue Council, as well as a wildlife artist and a carver of walking sticks.

Bonelyn Lugg Kyofski — A storyteller of local history and folklore to school children and community organizations, Bonnie is an Associate Professor in Education at Mansfield University.

Patricia Miner Macneal — An independent consultant, Pat helps traditional artists and arts organizations in Central Pennsylvania and the Northern Tier. She also gardens and plays the organ.

Douglas Manger — Douglas was a folklorist fieldworker for the Northern Tier Documentation Project in 1992. Since then he has done other folklore related work in Pennsylvania, Florida, and Texas.

Leonard Parucha — Before retirement, Leonard papered and painted most of the houses in the Lock Haven Historical District. Now he collects folktales and stories of Polish people during World War II.

Kenn Reagle — A folklorist in the 1992 project, Kenn has recently worked with the Lycoming County Bicentennial Project. Preaching, teaching, and storytelling are primary areas of interest.

Sandra B. Rife — The director of the Lycoming County Historical Society, Sandy has an avid interest in local history and folkarts, and knowledge and experience in the field of archeology.

Kenneth A. Thigpen — An Associate Professor of English at Penn State, Ken has been an active folklorist for many years. He founded the Documentary Resource Center and makes documentary videos.

Ruth Tonachel — A mother of two, Ruth takes time to research and write on local folkways and traditional arts. She also edits

the newsletter for the Pa. Association for Sustainable Agriculture.

Sylvia L. Wilson — As curator of the Bradford County Heritage Association's Farm Museum in Troy, Sylvia writes articles about events and artifacts at the Museum for the Towanda *Daily Review.*

Local historian Wilson Ferguson, Forest District Manager Robert Martin Jr., agricultural consultant David P. Winton, and art historian Eugene Seelye were most helpful in writing the County Overviews.

Sources of Further Information about Pennsylvania's Northern Tier

County Resources

Bradford County Historical Society
 21 Main Street
 Towanda, PA
 717-265-2240

Bradford County Heritage Association Farm Museum
 Box 265
 Troy, PA. 16947
 717-297-3410

Cameron County Historical Society
 139 E. Fourth St.
 Emporium, PA 15834
 814-486-3717

Clinton County Historical Society and Heisey Museum
 362 E. Water St.
 Lock Haven, PA 17745
 717-748-7254

Lycoming County Historical Society and Museum
 858 West Fourth St.
 Williamsport, PA 17701-5824
 717-326-3326

Potter County Historical Museum
 308 N. Main St.
 Coudersport, PA 16915
 814-274-8124